40 DIGITAL PHOTO
RETOUCHING
TECHNIQUES

Y.

ISBN: 89-314-3502-9

Printed and bound in the Republic of Korea.

How to contact us

E-mail: support@youngjin.com
feedback@youngjin.com.sg
Address: YoungJin.com
1623-10, Seocho-dong, Seocho-gu
Seoul 137-878
Korea
Telephone: +65-6327-1161
Fax: +65-6327-1151

Senior Manager: Deborah Joung
Chief Editor: Suzie Lee
Acquisitions and Developmental Editor: Bonnie Bills
Production Editor: Dennis Fitzgerald
Senior Editor: Angelica Lim
Copyeditor: Carol Loh
Proofreader: Semtle
Book and Cover Designer: Litmus
Production Control: Ann Lee

The aim of this book and the others in the Go Digital series is to show you how to use a simple tool to produce professional work that you can be proud of, whether you are a commercial photographer or hobbyist. Although you may master Photoshop Elements by the end of this book, the focus here is on producing sophisticated-looking results in as short a time as possible.

On the other hand, this book may be results-oriented but it is not short on good pedagogy. If you have no prior knowledge of any image-editing software, a good way to approach this book is to read the Introduction: Warming Up to Photoshop Elements, which contains all of the background information and basic skills you need to try out the techniques.

If you have some experience with an image-editing software, you can pick any of the 40 techniques and blast off to the planet of professional-looking images right away. All of the examples used in this book are separate, individual projects carefully selected for their educational value, industry relevance, and artistic quality. Each of these techniques also contains explanations, tips, and shortcuts that will make everything that much easier to understand.

Anyway, enough said. Let's have fun!

Zack Lee

Contents

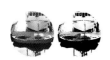

40 Digital Photo
Retouching Techniques

Warming Up to Photoshop Elements

Photoshop Elements is an easy-to-use image-editing program designed specifically for novice users and amateur photographers. It comes with all the basic features of Photoshop, a popular graphics software used by commercial artists and designers, but at only a fraction of the cost. Compared to Photoshop, Photoshop Elements has a significantly simpler editing process; its novice-friendly interface allows you to quickly and effortlessly correct, enhance, and retouch images.

In this book, you will learn how to edit and work creatively with your images in Photoshop Elements. From Chapter 1 onward, you will explore 40 real-life techniques listed in the order of difficulty and grouped thematically. But before you jump into editing mode, it is a good idea to read this chapter for an introduction to the key features of Photoshop Elements and for some background knowledge about computer graphics editing.

Key Features

Focus on image retouching

Photoshop Elements may be a cut-down version of Photoshop, but the user experience is completely different. The most obvious difference is that classic Photoshop features and functions have been reorganized or tailor-made to suit photography enthusiasts. The program is great for retouching images, such as sharpening blurred pictures, correcting overexposure, and fixing red-eyes. All these can be done with a few clicks of the mouse or by changing a few parameters' values.

▲ Red eyes caused by using flash

▲ Using the Red Eye Brush Tool to fix red eyes

▲ Original image

▲ Changing the color of the car

Online help and hints

Photoshop Elements is ideal for beginners, as it is very easy to use. It provides extensive online hints and help, complete with illustrations and explanations of how the different tools are used.

▶ Hints and How-To palettes guide you step-by-step and even perform some of the steps for you.

Creative photography

Photoshop Elements enables you to color images or enhance them by adding a picture frame, snow, or a myriad of other special effects. You can also combine several images together to create a unique mosaic.

▲ Creative image retouching using the Brush Tool

▲ Blending a picture of an artist's mannequin into the beach.

▲ Original picture of the baby

▲ Adding a picture frame and text effects

Flexibility

Using Photoshop Elements, you can arrange separate images on the same page for printing. You can also save images for use on the Web.

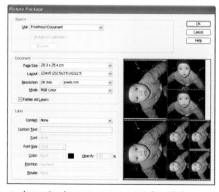

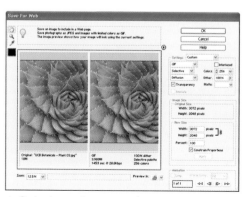

▲ Arranging images on one page for printing

▲ Saving images for use on web pages

Understanding Pixels and Resolution

What are pixels?

If you blow up a scanned image or a picture taken using a digital camera, you will see that the image is composed of small squares. These small squares are the smallest unit in an image and they are called pixels (short for picture elements). An image usually contains thousands of such pixels, each with its own color information and packed closely together. Optical illusion causes our eyes to take in the composition of pixels as a complete image. When you modify a certain area of an image, you are actually changing the pixels within that area. How well you modify these pixels will determine the quality of the final picture.

▲ The image at its original size

▲ The more you magnify the image, the more apparent the pixels become.

What is image resolution?

Image resolution refers to how compactly pixels are packed in an image. Image resolution is measured in pixels per inch (ppi). A resolution of one pixel per inch (1 ppi) means that there is one pixel in an area measuring one inch by one inch. A resolution of 10 pixels per inch (10 ppi) means that there are 10 pixels along each side of the same one-inch square. Thus, the higher the resolution, the more pixels there are in the image, and the better the quality of the image because a higher resolution allows for more details.

The relationship between image resolution and file size

The resolution of an image has a direct impact on file size. Although the image quality gets better at higher resolutions, the file size also increases.

- The file size of the image on the right, which has a resolution of 300 ppi, is 1.23 megabytes (MB).

Image size: 1.23MB ▶

- The same image at 72 ppi has a smaller file size at 73 kilobytes (KB), since the image is made up of fewer pixels.

Image size: 73KB ▶

- At 36 ppi, the file size of this image is even smaller at 18 kilobytes.

Image size: 18KB ▶

The difference between low- and high-resolution images

The image shown has an area of 3.94 inches by 2.63 inches and a resolution of 180 ppi. This means that there are 709 pixels along the width of the image and 473 pixels along the height. This works out to a total of 709×473 or 335,357 pixels for the entire image.

▲ Image resolution: 180 ppi

▲ Width: 709 pixels, Height: 473 pixels

▲ Magnifying the image

ⓥ Units of resolution

Resolution may be measured in pixels per inch (ppi) or dots per inch (dpi). Ppi is used to refer to the number of pixels per inch in a digital image. The resolution of a scanned image, for instance, is measured in ppi. Dpi refers to the number of dots that a printer can print per inch. The resolution of a print out is measured in dpi. In Photoshop Elements, you can set the image resolution to pixels per inch or pixels per centimeters.

If you leave the image size alone and reduce the resolution to 72 ppi, there will be 283 pixels along the width and 189 pixels along the height instead. The image will have a total of 283×189 or 53,487 pixels.

Because you did not change the image size, there is no difference in the size of the printed image. The image, however, will be less sharp because the resolution is lower (72 ppi compared to the original 180 ppi). This image is of a lower resolution compared to the high-resolution image generated at 180 ppi.

▲ **Image resolution**: 72 ppi

▲ **Width**: 283 pixels, **Height**: 189 pixels

▲ Magnifying the image

Understanding Image File Formats

Photoshop Elements allows you to save image files in different formats for different purposes. Factors such as file size and quality have to be considered when choosing a file format. The following file formats are supported by Photoshop Elements:

dobe file formats

▶▶▶ Photoshop (✳.PSD, ✳.PDD)

These file formats are exclusive to Photoshop and Photoshop Elements. Files saved in these formats tend to be larger than other image file formats because all layer and channel information are also saved. Despite a larger file size, this format is useful because it allows you to work on the file as you left it when you open it again.

▶▶▶ Photoshop PDF (✳.PDF, ✳.PDP)

The Portable Document Format is the file format commonly used for sharing documents over the Internet due to its flexibility and widespread compatibility. Photoshop Elements recognizes the generic PDF format and also the Photoshop PDF format.

Generic PDF files, in general, are created using Adobe Acrobat. You can open generic PDFs in Photoshop Elements, but you can only save them in Photoshop PDF format. A file saved in Photoshop PDF format can only contain one page, while a generic PDF can contain multiple pages. You should also remember that when a generic PDF file is loaded into Photoshop Elements, hyperlinks and all other Adobe Acrobat attributes will be changed into images.

ile formats suitable for the Web

▶▶▶ CompuServe GIF (✳.GIF)

GIF, or Graphic Interchange Format, is a file format that saves images in 256 or fewer colors. Because of this, it is not suitable for most continuous-tone images but works well for images with large areas of solid colors and crisp details.

▶ ▶ ▶ JPEG (＊.JPG, ＊.JPEG, ＊.JPE)

 JPEG, an acronym for Joint Photographic Experts Group, is an image file format that retains all the color information of an image but reduces file size by selectively throwing away data.

JPEG is most useful for saving photographs and other continuous-tone images. Images can be compressed at different levels. A higher level of compression gives a smaller file size but also a lower image quality, while a lower level of compression results in a larger file size but a higher quality image.

▶ ▶ ▶ PNG (＊.PNG)

 PNG, or Portable Network Graphics, is a file format that was developed as an alternative to GIF and intended for web usage. Like GIF, PNG-8 supports 8-bit color depth or 256 colors and is suitable for images with few variations in color. PNG-24, on the other hand, supports 24-bit or 16,777,215 colors, which are about all our human eyes can see, so it is recommended for continuous-tone images. In addition, PNG-24 supports many levels of transparency, unlike JPEG.

ⓟrint and other file formats

▶ ▶ ▶ Photoshop EPS (＊.EPS)

 EPS, or Encapsulated PostScript, allows files to be shared with most graphics, illustration and page-layout programs, such as PageMaker and QuarkXPress. EPS images are best printed on PostScript-enabled printers. Many color separators and printers accept images in this format.

▶ ▶ ▶ BMP (＊.BMP)

 BMP, a standard image format used for Windows-compatible machines, allows you to set the color depth.

▶▶▶ PICT (∗.PCT, ∗.PICT)

PICT, the standard image format for Macintosh environments, allows for 16-bit and 32-bit color depth settings. It is especially suitable for compressing flat-color images.

▶▶▶ PCX (∗.PCX)

PCX is a bitmap file format widely supported on both Windows-compatible and Macintosh machines.

▶▶▶ TIFF (∗.TIF)

TIFF, or Tagged-Image File Format, is a flexible bitmap file format supported by most graphics, illustration, and page-layout programs. It is often used for cross-platform file exchange.

▶▶▶ Pixar (∗.PXR)

The PIXAR format, developed and named after the Pixar computer technology used in the making of the movie Toy Story, is used most frequently on PIXAR computers. It is also supported on the Macintosh.

▶▶▶ TGA (∗.TGA, ∗VDA, ∗.ICB, ∗.VST)

TGA, or Targa, is designed for systems using the Truevision video board. It automatically creates alpha channels that include 256 or fewer shadows, and it can be easily combined with background images in Photoshop Elements or other image-editing programs.

Touring the Photoshop Elements Interface

Let's take a brief look at the Photoshop Elements interface and its various features.

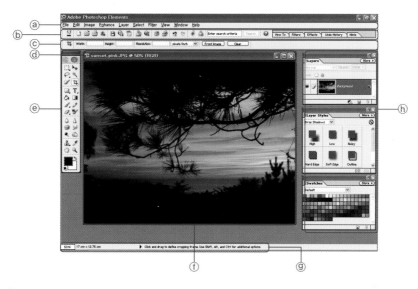

ⓐ Menu bar

The menu bar displays menus for the various commands available in Photoshop Elements. Clicking on a menu item will pull down the associated sub menu.

▲ Selecting [Image] from the menu bar

ⓑ Shortcuts bar

The shortcuts bar contains icons for commonly used functions, such as File, Save and Print. At the right end of the shortcuts bar is the Palette Well, which is used to store frequently used palettes. You can move the palettes in and out of the well by clicking and dragging on a palette tab.

▲ Click on the Filters tab in the Palette Well to view the Filters palette.

ⓒ Options bar

The options bar allows you to configure the options for a tool you selected.

ⓓ Title bar

When an image file is opened and the active image window is maximized, the title bar displays the name of the image file, the magnification at which the image is being viewed, and the image mode (bitmap, grayscale, indexed color, or RGB).

▲ The maximized image window

ⓔ Toolbox

The toolbox contains all the tools you need for working on images, including selection, drawing and painting, correction, and navigation tools. Placing the cursor over a tool will reveal the tool's name and the keyboard shortcut for accessing the tool. This text is called the tool tip. At the bottom of the toolbox are two color swatches that you can use to set the foreground color (i.e., your tool color) and the background color.

A small triangle at the lower-right corner of a tool indicates that the tool has additional tools associated with it. These are called hidden tools. Clicking the right mouse button or holding a left mouse button click on a tool will reveal the hidden tools.

ⓕ Active image area

This is the area where the current active image is displayed.

ⓖ Status bar

The status bar displays the status for the current image, namely the zoom ratio, the image dimensions, and information about the active tool.

ⓗ Palettes

Photoshop Elements comes with 11 palettes, each with different functions to help you monitor and modify images. The palettes can be accessed from the Window menu. You can keep the palettes in the Palette Well or leave them in the work area.

Filters Palette

Contains a list of available filters for creating special effects or removing image defects. The palette displays thumbnails of an image modified with each filter so you can see the results. Double-

Essential Photoshop Elements Know-How

Now that you have an understanding of the Photoshop Elements interface, we will devote the rest of this introduction to learning how to perform some essential steps in the program. In the following pages, you will learn how to open and save an image file, and change the view of the image window.

Opening an Image File

There are three ways of opening an image file in Photoshop Elements:

Using the [File]-[Open] command

1. Select [File]-[Open] from the menu bar.

 The Open dialog box appears.

2. Select the image file from its folder. Click Open.

 The selected file will appear in the Photoshop Elements image window.

 You can also open an image file using the keyboard shortcut Ctrl + O.

Double-clicking on an empty workspace

(1) Double-click on the empty workspace. This is the gray background where the image window will appear when a file is opened.

The Open dialog box appears.

(2) Select the image file from its folder. Click Open.

The selected image file will appear in the Photoshop Elements image window.

Using the file browser

(1) Select [File]-[Browse] from the menu bar.

The File Browser screen appears.

(V) **Keyboard Shortcut**

You can also open the File Browser using the keyboard shortcut Shift + Ctrl + O .

② Select the folder in the Search window at the upper left of the File Browser screen.

A preview of the images in the selected folder appears in the Image Files Preview window on the right.

③ Click on an image.

The thumbnail of the selected image and information about its size and format appear on the left of the File Browser screen.

④ Double-click on the selected thumbnail or drag it onto the empty workspace.

The selected file will appear in the Photoshop Elements image window.

💡 This method for opening images is great for selecting and loading images directly from the memory card of a connected digital camera.

A Closer Look at the File Browser Screen

The File Browser screen contains a number of features that allow you to view, sort, and process image files. Let's take a closer look at some of these features.

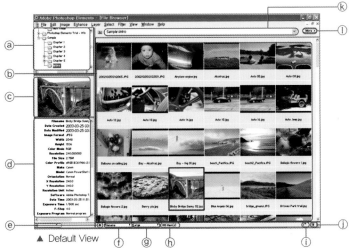

▲ Default View

ⓐ **Search window:** Displays the drives and folders on the computer. Click a folder to see its contents in the Preview window on the right.

ⓑ **Image File Preview window:** Displays the thumbnails of all the image files contained in the folder selected in the Search window.

ⓒ **Preview window:** Shows a larger thumbnail of the image selected in the Image File Preview window.

ⓓ **File Information window:** Shows the name, size, format, and creation and modification dates of the selected image file.

ⓔ **Toggle Expanded View button:** Toggles between showing all the windows in the File Browser or just an expanded view of the Image Files Preview window.

Expanded view ▶

ⓕ **Sort By pop-up menu:** Provides sorting options such as file size and file name for the image files or folders in the preview window.

ⓖ **View By pop-up menu:** Provides four viewing options, including three thumbnail sizes and a details view which displays the thumbnail beside the file information.

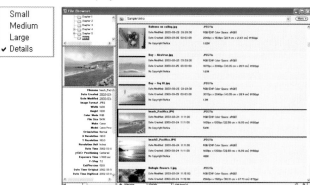

▲ Setting the view to Details.

ⓗ **Items:** Shows the number of image files or folders in the preview window.

ⓘ **Rotate button:** Rotates the selected image at 90-degree intervals, clockwise or counterclockwise, before loading into Photoshop Elements. This option is not available to image files saved on the desktop.

ⓙ **Delete button:** Deletes the selected file.

ⓚ **Pathname:** Displays the path of the selected folder in the Search window.

ⓛ **More button:** Displays the File Browser menu.

Saving an Image File

Using the [File]-[Save] command

Select [File]-[Save] from the menu bar to save the image file using the same name and in the current file format. If you save an image using [File]-[Save], the original image will be overwritten by the changes made.

Using the [File]-[Save As] command

(1) Select [File]-[Save As] from the menu bar.

The Save As dialog box appears.

(2) Type in the file name and select the image format.

(3) Click Save.

Using the [File]-[Save for Web] command

(1) Select [File]-[Save for Web] from the menu bar.

The Save for Web dialog box appears.

(2) Click OK.

The Save Optimized As dialog box appears.

(3) Type in the file name. Click Save.

(V) **Keyboard Shortcuts on the Macintosh**

Photoshop Elements runs on both the Windows and Macintosh operating systems. The program functions the same on both platforms, but there are a few keyboard differences. For example, the shortcut to open a file in Photoshop Elements is Ctrl + O in Windows; it's Command + O on the Mac.

Throughout this book, the keyboard shortcuts given are based on the Windows platform. Mac users should have no problem following along if they learn a few keyboard equivalents:

Windows	Macintosh
Shift	Shift
Alt	Option
Ctrl	Command (or "apple" key)
right-click	Ctrl +click

A Closer Look at the Save As Dialog Box

The Save As dialog box lets you define how an image file should be saved. Let's look at some of the options.

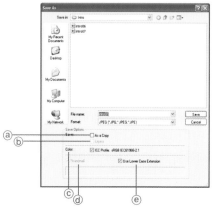

ⓐ **As a copy**: Check this option to save the image file as a copy, leaving the original image intact. The new file has the word "copy" in the file name.

ⓑ **Layers**: This feature will be activated if you have used layers in the image file. Check this option to preserve the layers. If you do not check this option and save the image as an image file (whether JPEG or other file formats), the layers will be merged with the background layer.

ⓒ **Color**: Check this option to save the color information of the image.

ⓓ **Thumbnail**: Check this option to create a thumbnail for the saved image file. This thumbnail will be shown in the Open dialog box when the [File]-[Open] command is selected.

🔘 Changing the Thumbnail Option

By default, the Thumbnail option is selected. To change the setting, select [Edit]-[Preferences]-[Saving Files] from the menu bar. When the Preferences dialog box appears, select an option from the Image Previews drop-down menu.

ⓔ **Use Lower Case Extension**: Check this option to have the file format extension displayed in lower case. If not selected, the file format extension will be displayed in upper case.

A Closer Look at the Save for Web Dialog Box

The Save for Web dialog box allows you to adjust settings that determine the size and quality of images saved for the Web and to save files as GIF animations. It also lets you preview the effects of the settings you make.

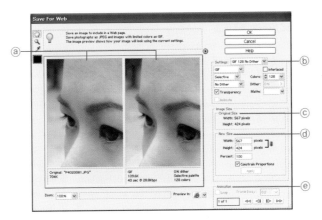

ⓐ **Preview Window**: Displays the original image on the left and the optimized image on the right. Also shows the file size and loading time for each image.

ⓑ **Settings**: Displays the compression file formats and color depth options available.

ⓒ **Original Size**: Displays the image size and resolution of the original image.

ⓓ **New Size**: Allows changing of the image size and resolution.

ⓔ **Animation**: Saves file as an animated GIF file.

Ⓥ Why Optimize?

A large, high-resolution image will take a long time to load on a web page. To keep downloading speed fast, images need to be saved in one of the compression file formats and settings need to be adjusted in order to preserve the best possible quality at the smallest possible size. This process is known as optimizing an image.

Changing the View

As it is often necessary to zoom in on certain parts of an image for more detailed work, this section describes how you can use the Zoom Tool and the Hand Tool to change the view of the image.

Zooming in on a selected area

1 Select the Zoom Tool (🔍) from the toolbox.

2 Click and drag over the area you wish to magnify.

The selected area will be magnified and shown in the active image window.

🔘 The zoom ratio is shown on the title bar at the top of the window.

Zooming in on the entire image

1 Select the Zoom Tool (🔍) from the toolbox.

2 Click on the image window to magnify the entire image.

Zooming out of an Image

① Select the Zoom Tool (🔍) from the toolbox.

② Hold down Alt .

The mouse pointer changes to 🔍 .

③ Click the image to zoom out.

(tip) Press Ctrl + Spacebar to change the cursor or selected tool to the Zoom In Tool. Press Alt + Spacebar to convert to the Zoom Out Tool.

Moving the magnified image

After you have zoomed in a few times on an image, you may no longer be able to see the entire image in the image window. In such cases, you must use the Hand Tool to move your view to another part of the image.

① Select the Hand Tool (✋) from the toolbox.

② Click and drag the tool in the image window to move the image.

(tip) Press and hold down the spacebar to switch from a selected tool to the Hand Tool.

Using keyboard shortcuts

▶▶▶ `Ctrl` + `0`

Resizes the image to fit the Photoshop Elements window so the entire image is visible.

▶▶▶ `Ctrl` + `Alt` + `0`

Displays the image at 100% view.

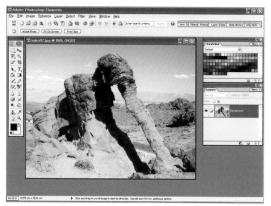

▲ The image fits the Photoshop Elements window nicely.

▲ The title bar shows the magnification at 100%.

▶▶▶ `Ctrl` + `+`

Zooms into the image without changing the actual image size.

▲ Holding down the `Ctrl` key and pressing the `+` three times.

 Ctrl + **−**

Zooms out of the image and fits the image window around it.

▶ ▶ ▶ **Ctrl** + **Alt** + **−**

Zooms out the image and fits the image window around it.

▲ Holding down the **Ctrl** key and pressing **−** two times

▲ Pressing **Ctrl** + **Alt** + **−** two times

 Ctrl + **Alt** + **+**

Zooms into the image and fits the image window around it.

◀ Pressing **Ctrl** + **Alt** + **+** two times

40 Digital Photo
Retouching Techniques

Correcting Contrast

If you are a photography enthusiast, you know that light is the defining factor in photography. You probably also know that getting the perfect lighting conditions for the right exposure is sometimes out of your control. Backlit photos, for instance, are sometimes unavoidable.

In this chapter, you will learn to evaluate the contrast of an image in Photoshop Elements and correct the problem like a pro. In addition, you will make an out-of-focus picture appear more focused by increasing the contrast of the image.

Diagnosing the Problem

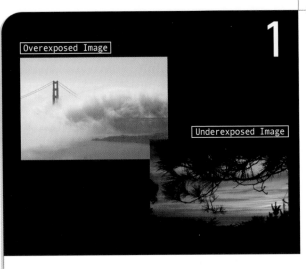

One of the most common problems in taking pictures is getting the right exposure. Although you can tell just by looking whether an image is under or overexposed, you can make more accurate corrections if you use the Histogram function in Photoshop Elements.

About the histogram

The histogram works by mapping the number of pixels at each tonal value. If the pixels are concentrated in the shadows, this means that the image has more dark areas. An image with pixels more or less evenly spread across the histogram would have a full tonal range. By understanding the information provided in the Histogram dialog box, you will know exactly which part of the histogram needs adjustment when correcting the image tone.

Analyzing an overexposed image

① Select [File]-[Open] from the menu bar.

The Open dialog box appears.

② Open the **Sample\Chapter 1\Tech0101.tif** file from the supplementary CD.

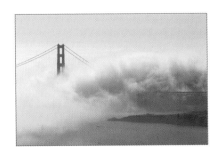

③ Select [Image]-[Histogram] from the menu bar. When the Histogram dialog box appears, check that **Luminosity** is selected under the Channel option.

Notice that the right side of histogram is extremely high. This is an indication that the image is too bright. Such an image is known as a high-key image.

④ Click OK to close the Histogram dialog box.

(tip) You can also choose to plot the intensity of the reds, greens, and blues in the image if you are working with an RGB image.

Analyzing an underexposed image

① Select [File]-[Open] from the menu bar.

The Open dialog box appears.

② Open the **Sample\Chapter 1\Tech0102.tif** file from the supplementary CD.

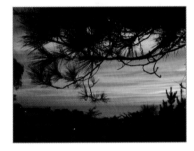

③ Select [Image]-[Histogram] from the menu bar.

The Histogram dialog box appears. In contrast to the previous histogram, the left side of this histogram is very high. This is an indication that the image is too dark. Such an image is called a low-key image.

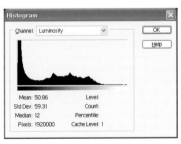

(tip) Other than high-key and low-key images, average-key images also need to be fixed. Average-key images are those with a concentration of pixels in the middle portion of the histogram. These images tend to look dull because they are dominated by grays or midtones.

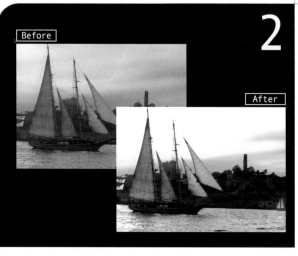

Before

After

2 Correcting Blurred Images

If your image is slightly out of focus, you can increase the brightness and contrast of your image to make it appear sharper. If you have a very blurred image, however, there is no way that you can make it look focused. The best thing to do is to shoot the photo again. Always remember the GIGO (pronounced gee-go) principle. GIGO is short for Garbage-In Garbage-Out. It is a computer term to describe that the output will only be as good as the input.

(1) Select [File]-[Open] from the menu bar.

The Open dialog box appears.

(2) Open the **Sample\Chapter 1\Tech02.tif** file from the supplementary CD.

(3) Select [Enhance]-[Adjust Brightness/Contrast]-[Brightness/Contrast] from the menu bar.

The Brightness/Contrast dialog box appears.

(4) Set Brightness to **20**. Click the Preview checkbox to view the effect without closing the dialog box.

Note that the image is now brighter.

(tip) Always preview the image when making changes to the contrast. This is to make sure that the colors are not compromised for the sake of sharpness.

⑤ Set Contrast to **40**.

This makes the image look sharper.

🔖 In most cases, setting the Contrast to twice the Brightness value you just entered will produce the best results.

⑥ Click OK.

🔖 You can also change the brightness or contrast by using the slider bars, but typing in a value is quicker and more accurate–especially if you want to apply the same setting to a few images.

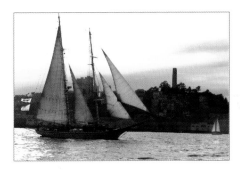

🔖 Press the [Alt] key to change the Cancel button to the Reset button. You can then reset the Brightness and Contrast values to 0 by clicking the Reset button.

🔖 Generally speaking, you must adjust the contrast whenever you change an image's brightness. If you brighten up an image without adjusting the contrast, its shadows will look too bright, making the image look like a faded photo.

In the following example, the Contrast has been increased to 80. We can see that this level of contrast does not accurately portray the tonal range of the image. At an even higer level of contrast, the image will be turned into a black-and-white image.

How the Pros Do It

3

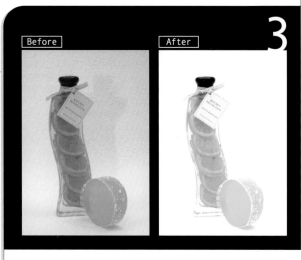

Before

After

Commercial photography usually requires sophisticated equipment that is beyond the budget of most hobbyists and amateur photographers. Using the Levels command in Photoshop Elements, you can correct and enhance product images taken using digital cameras to achieve professional-looking results.

Brightness/Contrast versus Levels command

While the Brightness/Contrast command can be used to change the brightness and contrast of an image, the Levels function is more sophisticated because you can make specific changes to the shadows, highlights, and midtones of an image.

① Select [File]-[Open] from the menu bar.

The Open dialog box appears.

② Open the **Sample\Chapter 1\Tech03.tif** file from the supplementary CD.

This image is a little dull so let's brighten it to give the objects a fresh appeal.

③ Select [Enhance]-[Adjust Brightness/Contrast]-[Levels] from the menu bar.

🔘 Some users magnify an image to view a particularly problematic or important section when making changes to contrast. Although this is a fast way of correcting glaring weaknesses, it makes it difficult to obtain an optimal overall image setting. Therefore, it is recommended that a contrast that is appropriate for the overall image be applied before the image is magnified.

④ The right side of the histogram in the Levels dialog box is quite high, indicating that the image is quite bright. Drag the white triangular slider directly below the Input Levels histogram from the right to the left, as shown in the figure.

This brightens the already bright regions of the image and removes the light background tone.

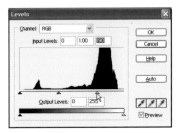

⑤ Drag the black triangular slider directly below the Input Levels histogram toward the right, as shown in the figure.

This darkens the darker pixels in the image and increases the overall contrast of the picture as a result.

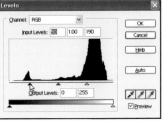

tip As you move a slider, the value in the corresponding Input Levels text field changes to reflect the new input. You can also adjust the histogram by entering the values in the text fields directly instead of moving the sliders. This is especially useful if exact values are needed.

⑥ Drag the gray triangular slider toward the left to brighten the midtones of the image.

In this example, entering an intensity value of 50 in the first input Levels field (for the black slider) means that all pixels to the left of 50 will become black. A value of 190 in the third field (for the white slider) means all pixels to the right of 190 will become white. A value of 1.45 in the middle field brightens the midtone regions slightly.

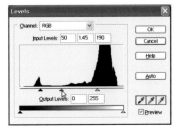

A Closer Look at the Levels Dialog Box

The Levels dialog box consists of a channel menu, a histogram, an input slider bar, and an output slider bar. The input slider bar is used to correct the brightness and contrast of images, while the output slider bar is used to set the tonal range of the image.

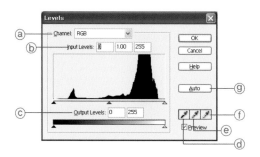

ⓐ **Channel:** You can adjust the intensity of an image's tonal values or its red, green, or blue values by selecting the channel from the drop-down menu.

ⓑ **Input Levels:** You can adjust the shadows, the midtones, and highlights of an image by entering the values in the Input Levels text fields or by adjusting the three input sliders below the histogram.

ⓒ **Output Levels:** You can change the overall image's tonal range by moving the two output sliders below the Output Levels text boxes. Dragging the white arrow toward the left darkens the overall image while dragging the black arrow to the right brightens the overall image.

ⓓ **Set Black Point:** If you click the Set Black Point eyedropper and then click on a pixel on the image, all pixels darker than the selected pixel in the image window will become black. Clicking this eyedropper on areas that are 100% black will have no effect.

ⓔ **Set Gray Point:** This is used to configure the midtones of the image. Clicking the Set Gray Point eyedropper on the image will apply the color contrast of the selected pixels as the midtone for the entire image.

ⓕ **Set White Point:** If you click the Set White Point eyedropper and then click on a pixel on the image, all pixels brighter than the selected pixel in the image window will become white. Clicking this eyedropper on areas that are 100% white will have no effect.

ⓖ **Auto:** You can automatically enhance the contrast of an image by clicking [Auto]. This option is the same as the [Enhance]-[Auto Levels] command in the menu bar.

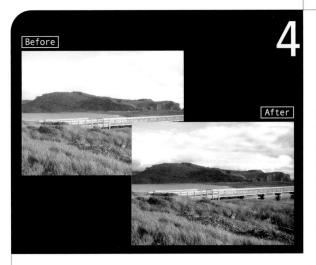

4 Correcting Backlighting

Backlighting often causes exposure problems in pictures. In the *Before* image on the left, the mountain is backlit by the bright, sunny sky. As you can see, the sky has ended up looking overly bright while the mountain and other parts of the image appear slightly dark. As a result of backlighting, the shot has suffered a loss in details since the camera cannot register the wide tonal range in the scene. The Adjust Backlighting feature in Photoshop Elements, however, will help you to correct such problems.

① Select [File]-[Open] from the menu bar.

The Open dialog box appears.

② Open the **Sample\Chapter 1\Tech04.tif** file from the supplementary CD.

This is an example of a backlit image. Another common example is a front shot of a person standing with his back to the light source.

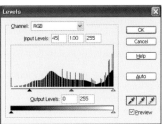

③ Select [Enhance]-[Adjust Brightness/Contrast]-[Levels] from the menu bar.

The Levels dialog box appears.

④ Set the values for the Input Levels to **45, 1.00,** and **255** to darken the overall image.

As the sky is too bright, the changes made in the Levels dialog box may not be very noticeable.

(5) Select the Magic Wand Tool (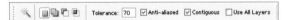) from the toolbox.

(6) Enter the settings in the options bar as shown.

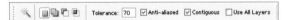

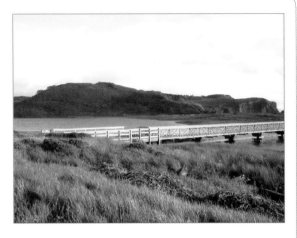

(7) Click on any point in the sky to select the entire sky.

💡 The Magic Wand Tool enables you to select an area of similar colors without having to trace the outline manually. You can specify the color range, or tolerance, of the tool to modify the range of its selection. The higher the tolerance value, the greater the number of colors included in the selection. Thus, a tolerance of 0 will not have any colors selected, while a value of 255 will have the entire image selected.

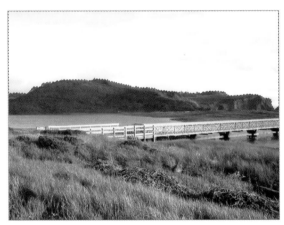

(8) Select [Enhance]-[Adjust Lighting]-[Adjust Back lighting] from the menu bar.

The Adjust Backlighting dialog box appears.

⑨ Set the Darker value to **40**.

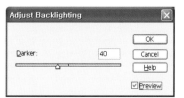

⑩ Click OK.

The sky becomes darker.

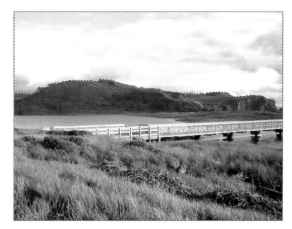

⑪ Select [Select]-[Deselect] from the menu bar.

This deselects the selection.

(tip) You can also use the keyboard shortcut [Ctrl]+[D] to deselect a selection.

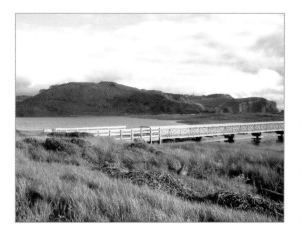

5 Brightening a Specific Spot

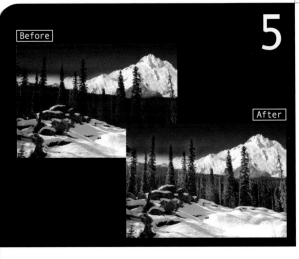

Occasionally, you may need to brighten or darken only specific areas of an image without affecting the other parts. To make such precise adjustments, you need to first select the area which you intend to work on. You would also have to make sure that the corrected area blends in with the image. All this can be done easily in Photoshop Elements.

1. Select [File]-[Open] from the menu bar.

 The Open dialog box appears.

2. Open the **Sample\Chapter 1\Tech05.tif** file from the supplementary CD.

 This snow-covered winter picture is too dark except for the areas covered by snow.

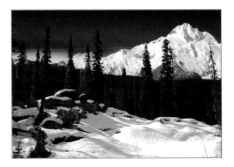

3. Select the Lasso Tool () from the toolbox.

4. Use the Lasso Tool to outline the dark areas.

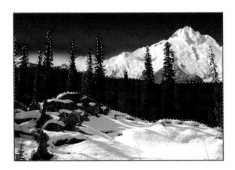

⑤ Select [Select]-[Feather] from the menu bar.

The Feather Selection dialog box appears.

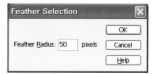

⑥ Set Feather Radius to **50**.

⑦ Click OK.

This softens the edges of the selection and blends it in with the rest of the image.

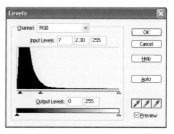

⑧ Select [Enhance]-[Adjust Brightness /Contrast]-[Levels] from the menu bar.

The Levels dialog box appears.

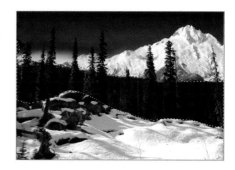

⑨ Set the Input values to **7, 2.3,** and **255.**

⊙ Check the Preview option in the Levels dialog box to preview the changes made in the dialog box on the actual image.

⑩ Click OK.

The selected areas become brighter.

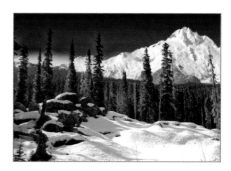

⑪ Choose [Select]-[Deselect] from the menu bar or press Ctrl + D .

This deselects the selection.

40 Digital Photo
Retouching Techniques

Manipulating Colors

You can tweak colors in Photoshop Elements as easily as a chameleon changes the color of its skin. In this chapter, you will learn a combination of techniques that will let you correct an image's color or create some interesting visual effects. For instance, you will learn to remove a color cast, turn an entire color picture or just a part of it black and white, create a sepia-toned image, and turn a photo of summer into fall. The best part is that by the end of this chapter, you will be able to create a multitude of new images from just one picture.

Before

After

6 Changing a Color

You can easily change the hue, saturation, and brightness of an image in Photoshop Elements with the Hue/Saturation command. This feature for improving overall colors is also useful when you only want to change a specific color. You can, for instance, make all the blues in the image appear darker without affecting the rest of the image. The command also lets you create monotone or duotone images from black-and-white or color images.

①　Select [File]-[Open] from the menu bar.

The Open dialog box appears.

②　Open the **Sample\Chapter 2\Tech06.tif** file from the supplementary CD.

In the following steps, you will learn to change the color of the car from red to blue.

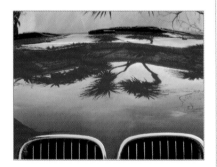

③　Select [Enhance]-[Adjust Color]-[Hue/Saturation] from the menu bar.

The Hue/Saturation dialog box appears.

④　Select **Reds** from the Edit menu.

Now you can only edit the red areas in the image.

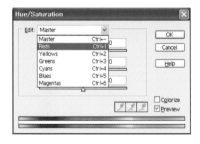

(5) Move the Hue slider to a value of **-110**.

This changes the color of the car from red to a purplish blue.

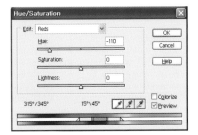
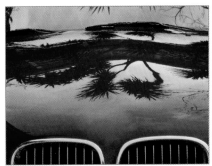

(6) Select **Magenta** from the Edit menu.

This limits you to editing the purplish areas in the image.

(tip) If you select Master from the Edit menu, your changes will affect the entire image. You can still change the color of the car in Master mode; but to do this, you will need to use the Lasso or Magic Wand Tools to select the car before changing the color values in the Hue/Saturation dialog box.

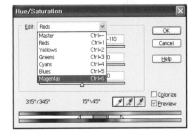

(7) Move the Hue slider to a value of **-100**.

This removes the purplish tones.

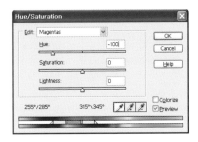
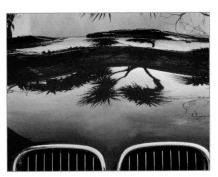

⑧ Move the Saturation slider to **+60**.

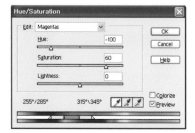

⑨ Click OK.

The car is now a brighter blue.

A Closer Look at the Hue/Saturation Dialog Box

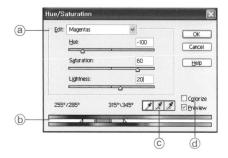

ⓐ **Edit:** You can choose to edit only one color in the image by selecting it from this menu. To edit all the colors in the image, choose Master.

ⓑ **Color Bars:** The top color bar shows the color distribution of the original image. The bottom color bar shows the color distribution after making the Hue adjustments.

ⓒ **Eyedropper:** The eyedropper is only available if you selected the Master option from the Edit menu. The eyedropper is useful for making adjustments to different colors on the image using the same values.

ⓓ **Colorize:** You can turn an image into a monotone (black and white) or duotone (black, white, and one color) by selecting this option.

7 Replacing a Color

Before

After

In this tutorial, we will use the Replace Color command to turn the purplish hue in the sky to light blue. Unlike the Hue/Saturation command, the Replace Color command lets you select the specific color and area for modification.

① Select [File]-[Open] from the menu bar.

The Open dialog box appears.

② Open the **Sample\Chapter 2\Tech07.tif** file from the supplementary CD.

③ Select [Enhance]-[Adjust Color]-[Replace Color] from the menu bar.

The Replace Color dialog box appears.

④ Select the Eyedropper Tool (✐).

⑤ Click on the purplish tones in the sky to select these areas.

The color selected using the Eyedropper Tool appears in the Sample window of the Replace Color dialog box.

⑥ Move the Fuzziness slider to a value of **130**.

> This selects the majority of the purplish areas in the sky so you can correct all the other purplish areas in addition to what you have already selected.

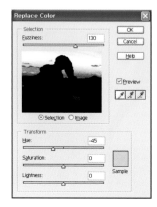

⑦ Move the Hue slider under Transform to a value of **-45**.

> The selected color turns bluish.

🔲 In the Replace Color Dialog box, check the Selection option in order to view the extent of your selection in the preview box. The white areas represent the areas selected for modification, while the black areas will not be affected by any color corrections made.

⑧ Click OK.

> The image now has the original bluish tone, instead of a reddish one.

Chapter 2

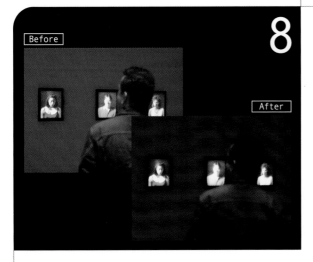

Before

After

8 Desaturating Part of the Image

When you turn a color image into black and white using the Remove Color command in Photoshop Elements, the process is known as desaturation. In this chapter, you will learn to desaturate only part of a color image as the juxtaposition of color and black-and-white areas creates an interesting visual effect. This is a technique that is often used in creating print, video and digital works.

① Select [File]-[Open] from the menu bar.

The Open dialog box appears.

② Open the **Sample\Chapter 2\Tech08.tif** file from the supplementary CD.

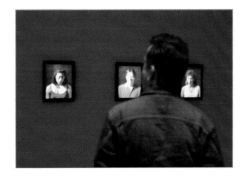

③ Pick the Selection Brush Tool () from the toolbox.

④ In the options bar, select a **Soft Round 100 pixels** brush from the brush presets pop-up palette and set Mode to **Mask**.

🔘 The Lasso Tool and the Magic Wand Tool are normally used to make detailed and exact selections. But in this example, a clear-cut border between the color and black-and-white areas will make the image look unnatural. So the Selection Brush Tool is used instead to create a less obtrusive-looking border between the areas.

(5) Click and drag the Selection Brush Tool over the picture frames in the image.

The picture frames is painted over in red, indicating that a mask has been applied.

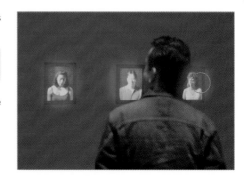

🔘 To remove from the selection, press the [Alt] key as you use the Selection Brush Tool.

(6) Change the Mode in the options bar to **Selection**.

The red mask color disappears and a selection border appears around the unmasked areas.

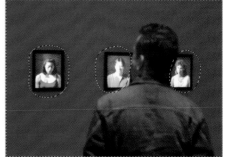

(7) Change the size of the brush to **27 pixels** in the options bar.

A smaller brush size lets you define a more precise selection border.

(8) Click and drag the Selection Brush Tool around the edges of the photos to add to the selection.

⑨ Select [Enhance]-[Adjust Color]-[Remove Color] from the menu bar.

This turns the selection into shades of gray.

⑩ Choose [Select]-[Deselect] from the menu bar or press Ctrl + D .

This deselects the selection.

⑪ Click and drag the Background layer in the Layers palette onto the Create a New Layer icon () to make a copy of that layer.

⑫ Press Shift + Ctrl + U to turn the copy into black and white.

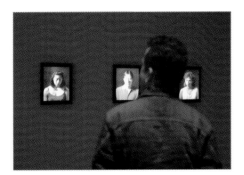

⑬ Select [Filter]-[Blur]-[Gaussian Blur] from the menu bar.

> The Gaussian Blur dialog box appears.

⑭ Enter a Radius of **7 pixels**. Click OK.

> This applies a blur to the copied black-and-white background layer.

⑮ Change the Blending Mode in the Layers palette from Normal to **Overlay**. By setting the Blending Mode to Overlay, the blurred Background copy acts as a screen through which the background shows. This has the effect of softening and blurring the entire image and keeping our interest on the colored areas.

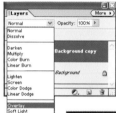

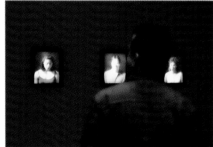

The Difference Between Grayscale Mode and Desaturation

At first glance, it may seem that there is no difference between turning images into black and white using the [Image]-[Mode]-[Grayscale] or the [Enhance]-[Adjust Color]-[Remove Color] commands. As you get more familiar with the program, however, you may soon realize that images turned into the Grayscale Mode cannot have their colors restored, but those desaturated using the [Enhance]-[Adjust Color]-[Remove Color] can be made as good as new. This is because desaturated images still have their color information intact.

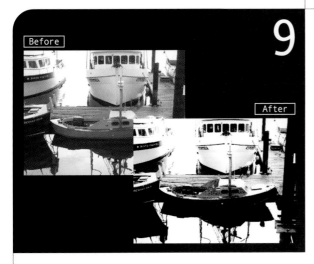

Turning Color Photos into Black-and-White Images

Sometimes, it is only after a shoot that I discover a shot would have looked better in black and white. On other occasions, I turn my color photos into black-and-white images at the model's request or because I need the pictures to create some special moods. Black-and-white images are particularly suitable for journalistic style photography or for evoking a sense of nostalgia. In this section, you will learn to turn a color image into a high-contrast black-and-white image in order to emphasize the lines and shapes in the image.

① Select [File]-[Open] from the menu bar.

The Open dialog box appears.

② Open the **Sample\Chapter 2\Tech09.tif** file from the supplementary CD.

③ Select [Enhance]-[Adjust Color]-[Remove Color] from the menu bar.

This removes all the color information so the color image changes to one in shades of gray.

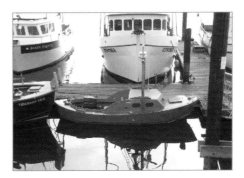

④ Select [Enhance]-[Adjust Brightness/Contrast]-[Levels] from the menu bar.

The Levels dialog box appears.

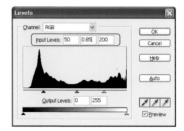

⑤ In the Input Levels text boxes, enter **50**, **0.85**, and **200**, respectively.

⑥ Click OK.

This will increase the highlights and midtones in the image.

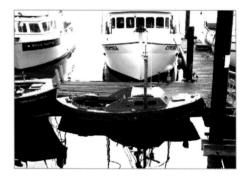

⑦ Click and drag the Background layer in the Layers palette onto the Create a New Layer icon () to make a copy of the layer.

⑧ Select [Image]-[Adjustments]-[Threshold] from the menu bar.

The Threshold dialog box appears.

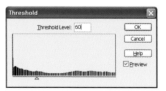

⑨ Move the Threshold Level slider to a value of **60**.

⑩ Click OK.

> The image changes from shades of gray to purely black and white.

💡 The Threshold command transforms color and grayscale images into high-contrast black-and-white images. Pixels lighter than the stated threshold value will be converted to white, while pixels darker than the threshold value will be turned into black. In general, the higher the threshold value, the more black the image will contain.

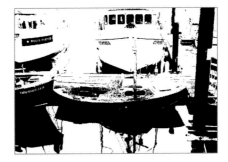

⑪ In the Layers palette, change the blending mode of all layers for which the Threshold Level has been changed to **Overlay**.

⑫ In the same palette, change the layers' Opacity to **60%**.

> The result is a high-contrast black-and-white image.

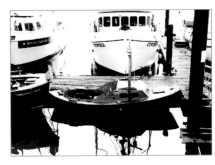

Coloring Black-and-White Photographs

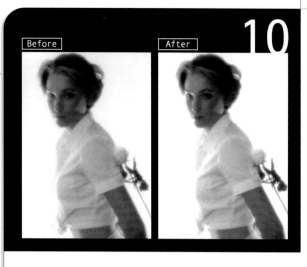

Before

After

If you have some old, black-and-white family photos, try turning them into color images in Photoshop Elements. The colors will inject vibrancy into the images and give them a different kind of look. But no matter how the images turn out, one thing is for sure—your pet project will get everyone in the family talking.

① Scan a black-and-white portrait shot(e.g. a black-and-white passport photo) and save it on your computer.

② Select [File]-[Open] from the menu bar. When the Open dialog box appears, look for the drive where you saved the scaned image and open it.

③ Select [Image]-[Mode]-[RGB Color] from the menu bar.

The RGB color mode is indicated on the title bar.

④ Select the Selection Brush Tool () from the tool-box.

⑤ In the options bar, set the brush size to **27 pixels**, the mode to **Selection**, and the hardness to **0%**.

⑥ Click and drag the tool over the model's skin to select it.

🔵 To make precise selections, you may need to change the brush size as you work. When selecting a small area, for instance, use a smaller brush size.

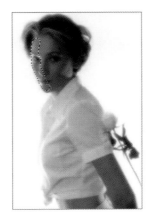

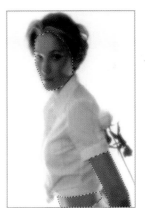

⑦ Select [Select]-[Save Selection] from the menu bar.

The Save Selection dialog box appears.

⑧ Enter the name **Skin** for the selection. Click OK.

🔵 Use [Select]-[Save Selection] from the menu bar to save selections, and use [Select]-[Load Selection] to load selections.

⑨ Press `Ctrl`+`U` or select [Enhance]-[Adjust Color]-[Hue/Saturation] from the menu bar.

> The Hue/Saturation dialog box appears.

⑩ Check the **Colorize** option. Set Hue to **10**, Saturation to **21**, and Lightness to **4**.

⑪ Click OK. Press `Ctrl`+`D` to deselect.

> This applies a flesh-tone to the woman's skin.

⑫ Select the Selection Brush Tool (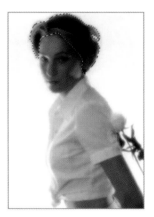) from the toolbox. Click and drag over the woman's hair to select it.

⑬ Select [Select]-[Save Selection] from the menu bar. Name the selection as **Hair** in the Save Selection dialog box. Click OK.

(14) Press `Ctrl`+`U` or select [Enhance]-[Adjust Color]-[Hue/Saturation] from the menu bar. Check the **Colorize** option, and set Hue to **23** and Saturation to **30** in the Hue/Saturation dialog box. Click OK. Press `Ctrl`+`D` to deselect.

> This changes the color of the woman's hair as shown.

(15) Select the Zoom Tool (🔍) from the toolbox. Click and drag the tool over the woman's face to magnify it, as shown.

(16) Select the Selection Brush Tool (🖌) from the toolbox. In the options bar, set the brush size to **9 pixels**. Click and drag the tool over the right pupil to select it.

(17) Press `Ctrl`+`U` or select [Enhance]-[Adjust Color]-[Hue/Saturation] from the menu bar. In the Hue/Saturation dialog box, check the **Colorize** option and set Hue to **260**, Saturation to **25**, and Lightness to **-15**. Click OK. Press `Ctrl`+`D` to deselect.

> This changes the color of the woman's eyes as shown.

18 Select the Selection Brush Tool () and set the brush size to **27 pixels** in the options bar.

19 Select the woman's cheeks.

20 Open the Hue/Saturation dialog box. Check the Colorize option and set Hue to **0**, Saturation to **25**, and Lightness to **0**. Click OK and deselect the cheeks. This adds color to the woman's cheeks.

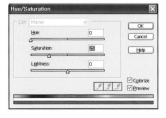

21 As in the preceding steps, use a selection brush of **9 pixels** in size to select the woman's lips.

22 Open the Hue/Saturation dialog box. Check the Colorize option and set Hue to **0**, Saturation to **25**, and Lightness to **0**. Click OK and deselect the lips. This changes the color of the woman's lips.

(23) Select the Burn Tool () from the toolbox. In the options bar, set Size to **2 pixels**, Range to **Midtones**, and Exposure to **30%**.

(24) Click and drag the tool over the woman's eyebrows and eyelids to sharpen the features.

🔘 Although you can correct the image with the Exposure set to 100%, this can over-enhance the effect you want to create. It is more effective to use a lower Exposure of 20% to 30% and then apply it several times to achieve the effect.

(25) Select [View]-[Actual Pixels] from the menu bar.

This displays the colored image in its actual size.

(26) Select the Selection Brush Tool () and set the brush size to **9 pixels** in the options bar. Select the rose petals and open the Hue/Saturation dialog box. Check the Colorize option, and set Hue to **35**, Saturation to **18**, and Lightness to **7** to change the color. Click OK. Press Ctrl+D to deselect.

▲ Changing the color of the rose petals

㉗ Next, select the leaves and open the Hue/Saturation dialog box. Check the Colorize option and set the Hue to **150**, Saturation to **15**, and Lightness to **-15** to change the color of the leaves.

▲ Changing the color of the leaves

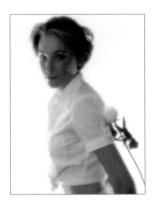

㉘ Select [Enhance]-[Adjust Brightness/Contrast]-[Brightness/Contrast] from the menu bar. In the Brightness/Contrast dialog box, set the Brightness to **15** and Contrast to **10**. Click OK. This changes the contrast of the image, as shown.

🔘 To preserve the selection borders you have made, you should save images in Photoshop's PSD file format. If an image is saved in another format, you could lose the selection borders.

11 Creating a Sepia-Toned Picture

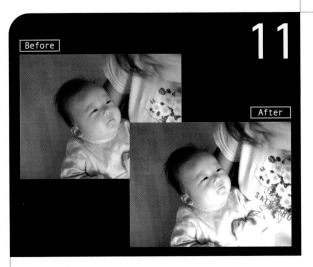

Before

After

Vintage photographs often come in a single color tone. A common example is the sepia-tone picture, which consists of predominantly brown tones. Sepia-toned images these days are usually people shots although this really depends on the photographer's preference. This section describes the steps needed to change colorful photographs into sepia-toned ones.

① Select [File]-[Open] from the menu bar.

The Open dialog box appears.

② Open the **Sample\Chapter 2\Tech11.tif** file from the supplementary CD.

③ Select [Enhance]-[Adjust Color]-[Remove Color] from the menu bar to turn the image into a black-and-white one.

④ Select [Enhance]-[Adjust Brightness/Contrast]-[Levels] from the menu bar.

The Levels dialog box appears.

⑤ In the Input Levels text boxes, enter the values **15, 0.95**, and **210** to increase the black-and-white contrast of the image.

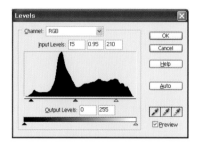

⑥ Click OK.

> The resulting image has a higher contrast level than the original one.

⑦ Select [Enhance]-[Adjust Color]-[Color Variations] from the menu bar.

> The Color Variations dialog box appears.

⑧ Click the Increase Red button twice to add reddish tones to the image.

⑨ Click the Increase Green button twice to add green-ish tones to the image.

> The result is a sepia-toned image.

🔘 In the Color Variations dialog box, keep your eye on the Preview window as you change the color. The image on the left is the original image and the image on the right is the modified image. To undo any changes and return to the original image, click the Reset Image button.

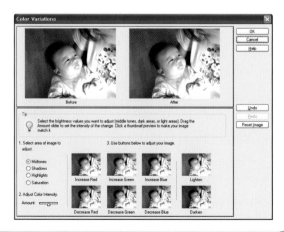

Blending Colors

When using the Color Variations dialog box to blend colors, you may find that the colors did not blend to produce the color you thought they would. This is because colors on a computer screen blend differently from color inks, which we are more familiar with.

In school, all of us learned the artist's color wheel which shows us how color inks combine to form new colors. The primary colors in an artist's color wheel are cyan, magenta, and yellow. Theoretically, these three colors should combine to form black, but the impurities in the inks produce a deep gray instead. In order to achieve pure black, color printers come with not only cyan (C), magenta (M) and yellow (Y) inks, but also a black (K) ink. So for printing, we use the CMYK color model.

▲ The artist's color wheel

The colors on a computer screen, however, are actually light rays so they do not have the same properties as color inks. The three primary colors of light are red (R), green (G), and blue (B). When these three colors are combined, we get white instead of black. Take some time to study the RGB color wheel, as shown here, so that you will find it easier to change colors on a computer next time.

▲ The RGB color wheel

12 Turning Summer into Fall

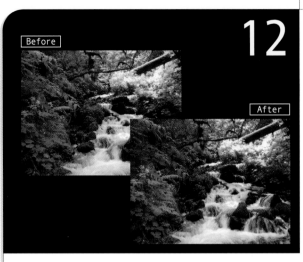

Every season has its representative colors—but to me, fall is the most colorful and most beautiful season. In this section, you will learn how to turn green summer leaves into reddish or yellowish autumn colors.

① Select [File]-[Open] from the menu bar.

The Open dialog box appears.

② Open the **Sample\Chapter 2\Tech12.tif** file from the supplementary CD.

③ Select [Enhance]-[Adjust Color]-[Hue/Saturation] from the menu bar.

The Hue/Saturation dialog box appears.

④ Change the Hue setting to **-30**.

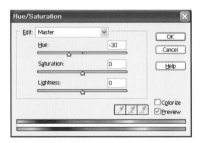

(5) Click OK.

The overall image now has a brownish tone.

(6) Select the Lasso Tool () from the toolbox.

(7) In the options bar, set Feather to **20 pixels**.

(8) Click and drag over a bunch of leaves on the left side of the image to select them.

(tip) To soften the edges of the selection border, always set a feather value greater than 0 before changing the color. The greater the feather value, the fuzzier the edges. A feather value of 0 will give the selection border an abrupt edge.

(9) Click the Add to Selection () icon in the options bar.

(10) Click and drag the tool over the leaves on the right side of the image to add them to the selection.

(11) Press [Ctrl]+[U] or select [Enhance]-[Adjust Color]-[Hue/Satu ration] from the menu bar.

> The Hue/Saturation dialog box appears.

(12) Set Hue to **-55** and Saturation to **+25**.

(13) Click OK.

> This changes the colors of the leaves to a warm autumn red.

(14) In the options bar of the Lasso Tool, (), click on the New Selection () icon.

(15) Select the leaves on the left side of the image, as shown.

(16) Click on the Add to Selection () icon in the options bar.

(17) Click and drag the tool over the other two areas, as shown.

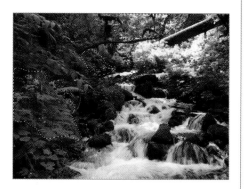

⑱ Press [Ctrl]+[U] or select [Enhance]-[Adjust Color]-[Hue/Saturation] from the menu bar.

The Hue/Saturation dialog box appears.

⑲ Set Saturation to **+65**.

⑳ Click OK.

This turns the selected areas yellow.

㉑ In the options bar of the Lasso Tool (◌), select New Selection (▣).

㉒ Select the leaves on the lower-left hand corner.

㉓ Open the Hue/Saturation dialog box. Set Hue to **-70**.

㉔ Click OK. Press [Ctrl] + [D] to deselect.

This turns the selected leaves slightly purplish.

40 Digital Photo
Retouching Techniques

Enhancing Portraits

While you can reshoot a landscape if you really want to, it is more difficult with portraits. You need to find another date and location that will fit into your model's schedule. In the worst-case scenario, you may never get the chance again. So instead of a reshoot, try correcting the offending portrait in Photoshop Elements. It will save you time, and you can even make your model better-looking than he or she really is.

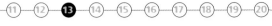

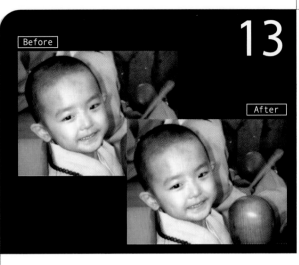

Before

After

13 Removing Red Eyes

When you use flash to take a picture of people and animals in a dark environment, your subjects can end up with red eyes. This effect is quite common, and you have probably seen such images before. In this section, you will learn to use the Red Eye Brush Tool to remove red eyes.

① Select [File]-[Open] from the menu bar.

The Open dialog box appears.

② Open the **Sample\Chapter 3\Tech13.jpg** file from the supplementary CD.

Note that the subject has red eyes.

③ Press Ctrl + Spacebar and click the image window to maximize the window to 150%.

This step is optional but highly recommended as you will need a magnified view to work on an area as small as the pupil of the eye.

Chapter 3

(4) Select the Red Eye Brush Tool () from the toolbox. In the options bar, set Brush to **Soft Round**, Size to **9 pixels**, Sampling to **First Click**, and Tolerance to **100%**.

(5) Click and drag the Red Brush Tool over the red spots until they turn dark gray.

 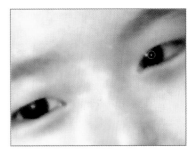

(6) Next, we need to add reflections to the pupils to make the eyes look more realistic. First, select the Brush Tool () from the toolbox. Set Brush to **Soft Round**, Size to **5 pixels**, Mode to **Normal**, and Opacity to **100%**.

(V) If the foreground color is not already set to white, click the Default Foreground and Background Colors icon () to set the foreground color to black and the background color to white, and then click the Switch Foreground and Background Colors icon () to swap the colors.

(7) Click on the pupils to add reflections.

 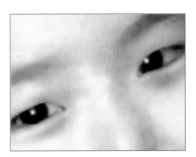

14 Removing Facial Blemishes

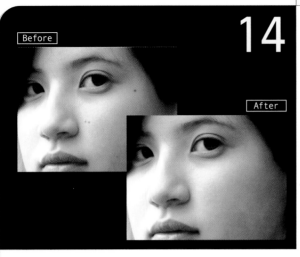

Before

After

The Clone Stamp Tool, which takes a sample of an image and lets you stamp it over an area, is very effective for removing unwanted artifacts such as dust and scratches from your photos. It is commonly used for removing specks from the sky in landscape photos and eradicating facial blemishes and scars from portraits. Let's see how it works in this tutorial.

① Select [File]-[Open] from the menu bar.

The Open dialog box appears.

② Open the **Sample\Chapter 3\Tech14.tif** file from the supplementary CD.

③ Select the Zoom Tool () from the toolbar. Click and drag over the image to magnify it as shown.

On closer inspection, we can see some spots on the model`s right cheek.

④ Select the Clone Stamp Tool () from the toolbar. In the options bar, set Brush to **Soft Round** and Brush Size to **50 pixels**.

⑤ Hold down the [Alt] key, and click on a flawless patch of skin near a spot to make a copy.

> As you hold down the [Alt] key, a crosshair appears in your circular pointer to indicate that you are in sampling mode.

⑥ Stamp on a spot.

> This copies the flawless skin from the previous step onto the blemish, thus covering it up. As every click will paint on more of the sample, the clone can become quite obvious if you stamp too many times.

⑦ Repeat steps 5 and 6 until all the spots are removed.

(8) Next, let's remove the redness from the model's face. Select the Sponge Tool () from the toolbox. In the options bar, set the Brush Size to **350 pixels** and Mode to **Desaturate**.

 You need to set the Sponge Tool to Desaturate in order to remove the color information from the skin.

(9) Click and drag this tool over the red areas to remove them.

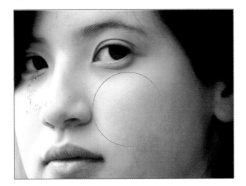

 When using the Sponge Tool () to remove color from the face, always check your progress as you go along because if you overdo it, you may end up with a black-and-white picture. If you did overdo it, change the mode to Saturate in the options bar. Then click and drag the tool over the area to enhance the color.

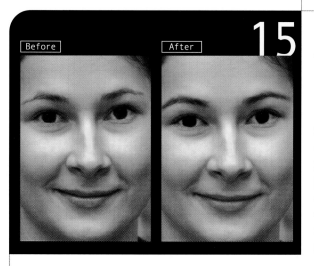

Before After

15

Applying Makeup

Some cosmetic counters or make-over studios are equipped with a computer system that captures a person's face and shows on screen the effect that their products will have on the face. It goes to show how easy it is now to change how a person looks using a computer. The most important thing you need to remember in this section is to keep the makeup natural.

(1) Select [File]-[Open] from the menu bar.

> The Open dialog box appears.

(2) Open the **Sample\Chapter 3\Tech15.tif** file from the supplementary CD.

(3) Press Ctrl + + to zoom in on the face.

(4) Select the Selection Brush Tool () from the toolbox. Set Size to **5 pixels**, Mode to **Mask**, and Hardness to **100%**.

(5) Click and drag over both eyeballs to apply a mask. With the eyeballs masked, you can apply eye makeup without getting any on them.

🔲 A masked area is protected from the changes made to the rest of the image. You can invert a masked area by clicking [Select]-[Inverse]. The previously unmasked areas will become masked instead.

(6) Click the Set Foreground Color icon in the toolbox.

The Color Picker dialog box appears.

(7) Set the RGB values to **0**, **246**, and **255** respectively.

(8) Click OK.

The foreground color changes, as shown.

(9) Select the Brush Tool () from the toolbox. In the Brush Tool options bar, set Size to **20 pixels** and Opacity to **15%**.

Reducing the opacity makes the color more transparent.

(10) Click and drag the Brush Tool () over the upper eyelids as if applying eye shadow.

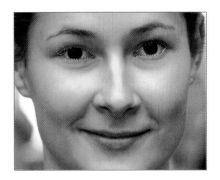

(11) Click the Set Foreground Color icon in the toolbox to change to another eye shadow color. In the Color Picker dialog box, set the RGB values to **0**, **12**, and **255**, respectively. Click OK.

This darker blue will be used for the inner edges of the upper eyelids.

(12) In the Brush Tool options bar, set Size to **12 pixels** and Opacity to **22%**.

The smaller brush size enables you to line the inner edges of the eyelids more accurately.

(13) Click and drag along the inner edges of the upper eyelids, as shown.

This completes the make-up on the upper eyelid.

(tip) Pressing [Ctrl] + [H] will hide the distracting, marching-ants selection border. Pressing [Ctrl] + [H] again will bring it back to view.

(14) Click on the Set Foreground Color icon in the toolbox. In the Color Picker dialog box, set the RGB values to **255**, **150**, and **0**, respectively. Click OK.

(15) In the Brush Tool options bar, set Size to **20 pixels** and Opacity to **10%**.

(16) Draw along the edges below the eyes.

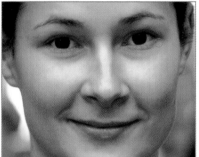

(17) Select the Burn Tool () from the toolbox. In the options bar, set Size to **5 pixels** and Exposure to **50%**.

(18) Click and drag over the edge of the eyelids as if applying eyeliner.

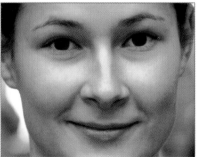

(19) In the options bar, set Size to **15 pixels**.

(20) Click and drag over the eyebrows to make them look more even.

(21) Note that the eye makeup has covered the eyelid lines. In the options bar, set Size to **5 pixels**. Click and drag the Burn Tool to draw the eyelid lines back in.

(22) In the options bar, set Size to **3 pixels**. Click and drag the Burn Tool outwards from the eyes as if applying mascara.

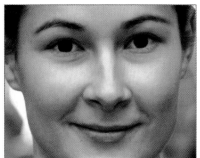

23 Click the Set Foreground Color icon in the toolbox to change to a lipstick color. In the [Color Picker] dialog box, set the RGB values to **251**, **6**, and **6**, respectively. Click OK.

24 Select the Brush Tool () from the toolbox. In the Brush Tool options bar, set Size to **15 pixels** and Opacity to **10%**.

25 Draw over the lips.

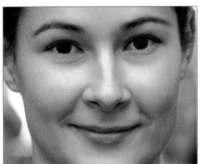

26 Select the Burn Tool () from the toolbox. In the options bar, set Size to **10 pixels**.

27 Click and drag the Burn Tool over the pupils in the eyes.

This darkens the pupils, making the eyes more prominent.

28 Press Ctrl + 0 to view the entire image.

Creating Bigger Eyes and a Sharper Chin

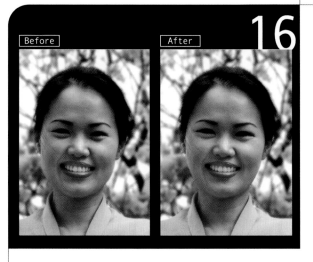

In this section, you will learn to use the Liquify command to make a face look slimmer with a sharper chin. You will also use the Free Transform function to make the eyes look bigger.

① Select [File]-[Open] from the menu bar.

The Open dialog box appears.

② Open the **Sample\Chapter 3\Tech16.tif** file from the supplementary CD.

③ Select [Filter]-[Distort]-[Liquify] from the menu bar.

The Liquify dialog box appears.

④ Select the Zoom Tool (🔍) in the Liquify dialog box. Click and drag over the right jaw line for a magnified view.

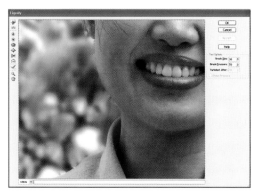

⑤ Select the Warp Tool () in the Liquify dialog box. Under Tool Options, set Brush Size to **30** and Brush Pressure to **50**.

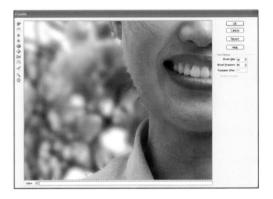

⑥ Click and drag the jaw line inward for a sharper chin.

🎯 A Brush Pressure of 50%, compared to, say 100%, will move the jaw line more gradually.

⑦ Click and drag the tool over the jaw line again to smooth out any rough edges.

⑧ Select the Hand Tool (). Click and drag the image to move the view to the other jaw. Select the Warp Tool () and repeat steps 7 and 8 on the left jaw line. Click OK.

◀ A slimmer–looking face

⑨ Select the Zoom Tool (🔍) from the toolbar. Click and drag over the eyes to zoom in on them.

⑩ Select the Lasso Tool (🔗) from the toolbar. In the options bar, set Feather to **12 pixels**.

⑪ Click and drag over the left eye to select it. Press Ctrl + C to copy the selection. Press Ctrl + V to paste the copy onto the image.

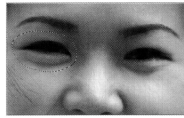

▲ Note that the copy is pasted on a new layer.

⑫ Select [Image]-[Transform]-[Free Transform]. A bounding box with adjustment handles will appear over the selection.

⑬ Hold down the Shift + Alt keys, and drag the adjustment handle on the lower right-hand corner slightly outward. Hit Enter .

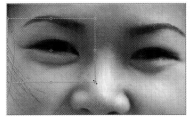

The Shift key ensures that the image is resized proportionally while the Alt key ensures that the image's center point remains unchanged. Always press the Shift key before the Alt key. Pressing the Alt key and then the Shift key will cause image distortion.

⑭ Repeat steps 11 to 13 for the other eye.

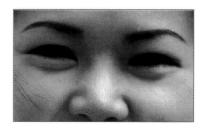

⑮ Press [Ctrl] + [0] to preview the entire image.

🔍 When modifying a face, always make sure that the results look natural. Don't go overboard or you may end up with awkward and unnatural features.

⑯ Select [Layer]-[Flatten Image] from the menu bar.

This combines all the layers created when you copied and pasted selections, and merges them with the Background layer.

⑰ Select [File]-[Save As] and save the completed image in a folder.

▲ Flattening the layers

🔍 The point of flattening layers is to reduce the file size–but before you do so, it is advisable to first save the image as a .PSD file, which retains layer information. If you flatten the layers without saving as a PSD file, you will not be able to access the layers again.

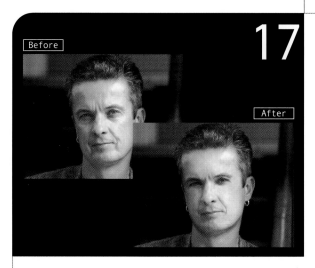

Before

After

17 Looking Young Again

With Photoshop Elements, you can easily remove wrinkles, cover gray hair and even out skin tone. In this section, I will show you how to take years off a person's face in a matter of minutes.

① Select [File]-[Open] from the menu bar.

The Open dialog box appears.

② Open the **Sample\Chapter 3\Tech17.tif** file from the supplementary CD.

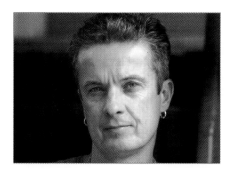

③ Select the Clone Stamp Tool (🖳) from the toolbox. In the options bar, set Size to **50 pixels**.

④ Hold down the [Alt] key and click on the patch of smooth skin below the right eye to create a clone.

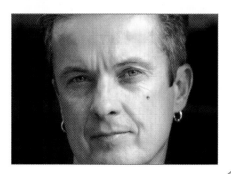

(5) Click and drag the Clone Stamp Tool over the lines below the eye.

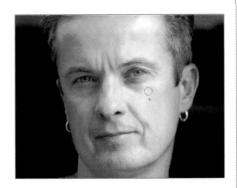

(6) Repeat steps 4 and 5 for the lines under the left eye.

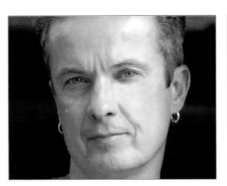

▲ Making a clone

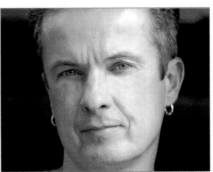

▲ Stamping out the wrinkles under the eyes

(7) Repeat steps 4 and 5 for the lines on the forehead and around the mouth.

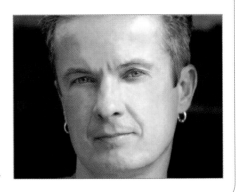

Most of the lines are removed ▶

⑧ Select the Dodge Tool (⦿) from the toolbox. In the options bar, set Size to **200 pixels** and Exposure to **30%**.

⑨ Click and drag the Dodge Tool over areas that appear brighter due to the lighting (for example, the forehead, the nose bridge, and the upper-left cheek).

This brightens up the skin tone.

(tip) The higher the Exposure value for the Dodge Tool, the brighter the results.

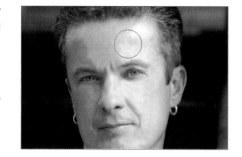

⑩ Select the Burn Tool (⦿) from the toolbox. In the options bar, set Size to **60 pixels** and Exposure to **30%**.

⑪ Click and drag the Burn Tool over the shadows on the face (for example, over the eyelids, the area below the jaw line and the right side of the face).

This enhances the shadows and gives more dimension to the face.

(tip) The higher the Exposure value for the Burn Tool, the darker the results.

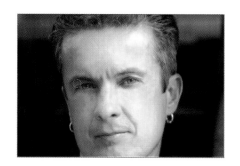

⑫ Next, let's change the hair color. First, select the Brush Selection Tool () from the toolbox. In the options bar, set Brush Type to **Soft Round**, Size to **100 pixels**, and Mode to **Mask**.

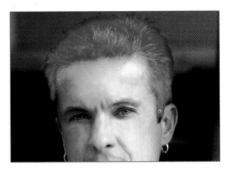

⑬ Click and drag over the hair to mask it, as shown.

⑭ In the options bar, set the Brush Size to **30 pixels** to select the hard-to-reach sections of the hair.

 If you inadvertently dragged the mask beyond the hairline, hold down the Alt key and drag over the unwanted areas to remove them from the selection.

⑮ Change the Mode to **Selection** to select the unmasked areas.

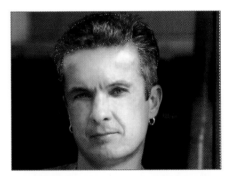

⑯ Press Ctrl + Shift + I to invert the selection and select the hair instead.

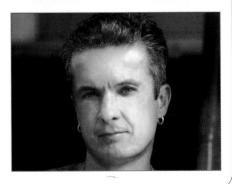

(17) Select [Select]-[Feather] from the menu bar. In the Feather dialog box, set Feather Radius to **10 pixels**. Click OK.

This softens the edges of the selection.

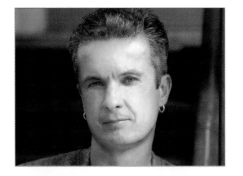

(18) Select [Enhance]-[Adjust Color]-[Color Variations] from the menu bar. In the Color Variations dialog box, click the Increase Green button. Click OK and press Ctrl + D to deselect.

This changes the hair color to green.

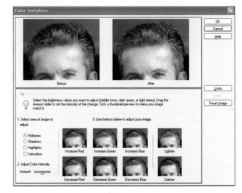

(19) Select the Sponge Tool () from the toolbox. In the options bar, set Size to **350 pixels**, Mode to **Saturate**, and Flow to **30%**.

(20) Click and drag the tool once over the entire face to give it a healthy glow.

To ensure that the change in saturation looks natural, use a large sponge size so that the effect is more spread out. You will only need to sponge the face once or twice.

At a low Flow value, the Sponge Tool saturates an area slightly, producing a soft effect. A high Flow value, in contrast, will produce stronger colors.

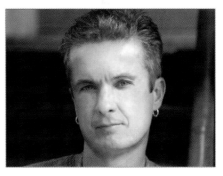

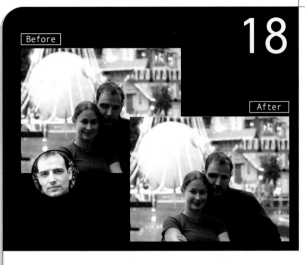

Before

After

18 Opening Closed Eyes

When taking group shots, the photographer cannot give everyone at the shoot his undivided attention, and so it is common to find one or two persons with their eyes closed in group photos. To make matters worst, group photos are usually taken to remember a special time or event. So if you find your subject's eyes closed in a special or important photograph, try this technique for opening closed eyes.

(1) Select [File]-[Open] from the menu bar.

The Open dialog box appears.

(2) Open the files **Sample\Chapter 3\Tech18.tif** and **Sample\Chapter 3\Tech18-1.tif** from the supplementary CD.

The subject`s eyes are closed in the first file and opened in the second. We will use the opened eyes to rectify the problem in the first picture.

(3) Select the Lasso Tool (⌗) from the toolbar. Set Feather to **7 pixels**.

(4) Select the eyes in the **Tech18-1.tif** image.

⑤ Select the Move Tool (🖐) from the toolbox. Click and drag the eyes from the **Tech18-1.tif** image to the Tech18.tif image.

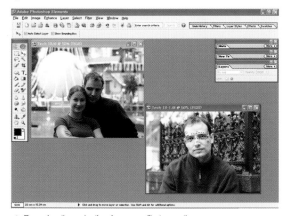

▲ Dragging the selection from one file to another

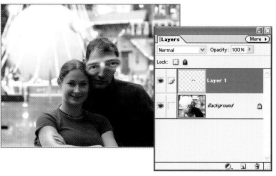

▲ The eye selection is added as a new layer.

⑥ Select [Image]-[Rotate]-[Flip Layer Horizontal] from the menu bar.

This flips the newly added eyes horizontally so that they are oriented the same way as the face.

▲ Fixing the orientation of the eyes

⑦ Select [Image]-[Transform]-[Free Transform] from the menu bar or press Ctrl + T .

The Free Transform bounding box appears.

⑧ Place the pointer over a handle at one of the corners.

The pointer changes to a double-headed arrow.

⑨ Hold down the [Alt] + [Shift] keys and drag the handle inward until the new set of eyes fits into the face. Press [Enter].

▲ Reducing the size of the eyes

⑩ Press [Ctrl] + [+] several times to zoom into the eyes. Select the Move Tool () from the toolbox and adjust the position of the eyes.

⑪ As you can see, the eyes are much brighter than the rest of the image. Let`s fix this using the Levels command. Select [Enhance]-[Adjust Brightness/Contrast]-[Levels] from the menu bar or press [Ctrl] + [L]. In the Levels dialog box, enter **23**, **0.77**, and **255** in the Input Levels text boxes, respectively. Click OK.

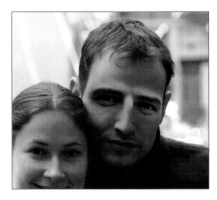

⑫ Select the Eraser Tool (⌐) from the toolbox. In the options bar, set Size to **30 pixels** and Opacity to **50%**.

⑬ Use the Eraser Tool (⌐) to erase as much of the skin as possible, leaving the eyes untouched.

This will minimize the difference in skin tone and make the face look more natural.

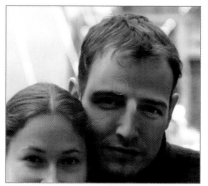

⑭ Press [Ctrl] + [0] to view the entire image.

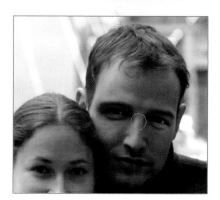

⑮ Select [Layer]-[Flatten Image] from the menu bar.

This combines the two layers into one.

▲ Combining the two layers

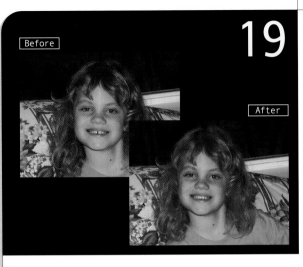

Before

After

19 Giving a Healthy Glow

Photoshop Elements can be used in the same way to give your subjects a healthy glow and bring the luster back to old, faded pictures. In this section, you will learn to make a pale-looking subject look livelier while filling in the gap between her front teeth.

① Select [File]-[Open] from the menu bar.

The Open dialog box appears.

② Open the **Sample\Chapter 3\Tech19.tif** file from the supplementary CD.

③ Select the Selection Brush Tool () from the toolbar. In the options bar, set Brush to **Soft Round**, Size to **20 pixels**, Mode to **Mask**, Hardness to **100%**, and Overlay Opacity to **50%**.

④ Brush over the face (excluding the eyes and mouth) and neck to mask them.

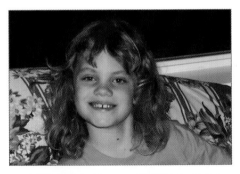

⑤ In the options bar, set Size to **5 pixels**. A smaller brush size enables you to select and add the hard-to-reach areas to the selection.

⑥ Select [Select]-[Inverse] from the menu bar.

This inverts the mask.

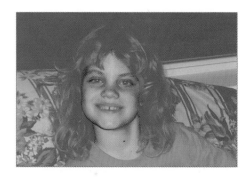

⑦ Select [Enhance]-[Adjust Color]-[Hue/Saturation] from the menu bar.

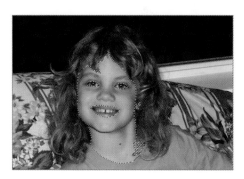

⑧ In the Hue/Saturation dialog box, set Hue to **-7**, Saturation to **+60**, and Lightness to **0**. Click OK.

The unmasked area is selected.

⑨ Click [Select]-[Deselect] from the menu bar to remove the mask.

The pinkish glow on the face and neck.

⑩ Select the Selection Brush Tool () from the toolbox. In the options bar, set Size to **3 pixels**. Select the lips to mask them.

⑪ In the options bar, set Mode to **Selection**. This will select the unmasked areas.

⑫ Select [Select]-[Inverse] from the menu bar.

This inverts the selection so that only the lips are selected now.

⑬ Select [Enhance]-[Adjust Color]-[Color Variations] from the menu bar. In the Color Variations dialog box, click the Increase Red button once. Click OK.

This gives the lips a healthy reddish tint.

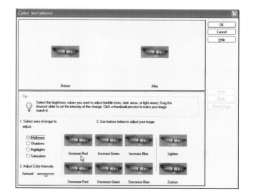

⑭ Press [Ctrl] + [D] to deselect the lips.

⑮ Repeat steps 10 to 12 for the hair, using a brush size of **20 pixels**.

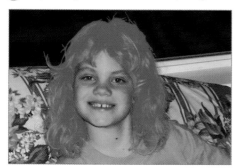

▲ Masking the hair

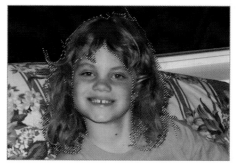

▲ Changing the mask into a selection

⑯ Select [Enhance]-[Adjust Color]-[Color Variations] from the menu bar. In the Color Variations dialog box, click the Increase Red button and then the Decrease Blue button.

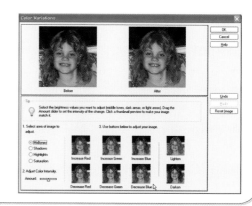

⑰ Click OK. The hair now has a healthier shine. Press [Ctrl] + [D] to deselect the hair.

(18) Select the Zoom Tool (🔍) from the toolbox. Click and drag the Zoom Tool over the two front teeth to magnify the area.

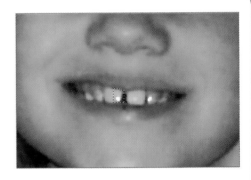

(19) Right-click on the Lasso Tool (🔗) in the toolbox and select the Polygonal Lasso Tool (📐) from the pop-up menu. Click and drag over the front teeth as shown.

(tip) The selection should reach up to the lips and include a little of the gap between the teeth.

(20) Select the Clone Stamp Tool (🖋) from the toolbox. In the options bar, set the Size to **10 pixels**.

(21) Hold down the Alt key and click on the left front tooth to make a clone.

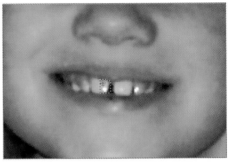

▲ Making a clone

(22) Stamp over the gap between the teeth.

▲ Covering the gap with a clone.

23 Press [Ctrl] + [D] to deselect. Repeat steps 19 to 22 for the right front tooth.

◀ Cloning the right front tooth

◀ Covering the gap with the clone

24 Press [Ctrl] + [0] to view the entire image.

20 Creating a Studio Background and Picture Package

If you need a passport photo for your job application or other sorts of forms but you don't have any, you can take a good portrait shot of yourself and alter the background to make it look like a studio backdrop. With Photoshop Elements, you can even print a picture package that is a collection of the same picture in different sizes.

① Select [File]-[Open] from the menu bar.

The Open dialog box appears.

② Open the **Sample\Chapter 3\Tech20.tif** file from the supplementary CD.

🔘 It is best to take portraits indoors. Pictures taken outdoors are generally brighter, and the exposure is difficult to adjust when retouching.

③ Select the Crop Tool (🔲) from the toolbox. In the options bar, set Width to **5 cm**, Height to **7 cm**, and Resolution to **200 pixels/inch**.

④ Click and drag over the image to produce a wallet-sized picture. Press ⎡Enter⎤ to crop the picture to the specified size.

<tip> Configuring the Crop Tool's options before cropping the image will save the settings so that the same settings can be used with the Crop tool the next time. To clear the tool settings, click the Clear button ([Clear]) in the options bar.

Standard Portrait Sizes	
Half Wallet Pictures	3 cm × 4 cm
Passport Pictures	3.5 cm × 4.5 cm
Wallet Pictures	5 cm × 7 cm

(5) Now, we will remove any blemishes from the skin. Select the Clone Stamp Tool (🖎) from the toolbox. In the options bar, set Size to **25 pixels**.

(6) Hold down the [Alt] key and click on a patch of clear skin below the right eye to make a clone. Next, release the [Alt] key and stamp over the spots below the right eye.

<tip> Try to create the clone from a nearby spot for a close fit in terms of lighting and skin tone.

<tip> Zoom in on the image for delicate retouching work.

▲ Cloning a patch of skin

▲ Covering up a blemish

(7) Hold down [Spacebar] to activate the Hand tool. Move the image to see the forehead. Repeat step 6 to remove the spot on the forehead.

⑧ Repeat the step until all the blemishes are removed from the face.

🔘 Avoid correcting large areas using the same clone patch. Make the changes progressively; change the brush size and use the [Alt] key to make a new clone each time.

⑨ Select the Dodge Tool (🔍) from the toolbox. In the options bar, set Size to **100 pixels**.

⑩ Click and drag the tool over the face and the hair to brighten up the entire image. As the left side of the face is darker, click and drag the tool over it a few more times to match the brightness on the right side.

🔘 The Dodge Tool is useful for adjusting different areas of an image to different levels of brightness, while the Levels menu applies the same brightness to the entire image.

⑪ Select [Layer]-[Duplicate Layer] from the menu bar to duplicate the Background layer. Click OK.

▲ The duplicate Background layer

⑫ Select the Smudge Tool() from the toolbox. In the options bar, set Brush to **Soft Round**, Size to **70 pixels**, and Strength to **50%**.

| Size: 70 px | Mode: Normal | Strength: 50% | ☐ Use All Layers ☐ Finger Painting |

⑬ Click on the background some distance away from the subject, and drag outward to blur the background.

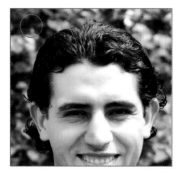 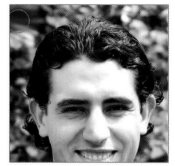

▲ Smudging the background

⑭ Repeat the process to smudge the area close to the subject.

🔘 The Smudge Tool simplifies the background by combining surrounding pixels.

🔘 If you accidentally smudged the image of the subject, press Ctrl + Z to undo.

⑮ We will now select the smudged background. First, select the Magic Wand Tool() from the toolbox. In the options bar, set Tolerance to **70**.

| Tolerance: 70 | ☑ Anti-aliased ☑ Contiguous ☐ Use All Layers |

(16) Click on the background to select it.

▲ Selecting the background ▲ The selection
using the Magic Wand Tool

(17) Hold down the [Shift] key and click on other parts of the background to add them to the selection.

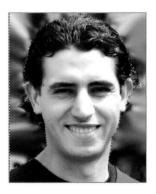

▼ Include only the background in the selection.

(18) If you accidentally selected the model, remove the selection by holding down the [Alt] key and clicking. To add more of the background, click while holding down the [Shift] key. Repeat until all the background areas have been selected.

(tip) You should adjust the Tolerance value of the Magic Wand Tool according to the size of the area you want to add to or remove from selection frames.

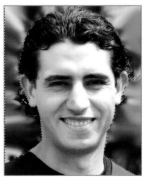

(19) Select [Select]-[Inverse] from the menu bar to invert the selection.

The subject is selected instead.

(20) Select [Layer]-[New]-[Layer via copy] from the menu bar to copy the selected image onto a new layer.

▲ Creating a new layer

(21) In the Layers palette, click the Indicates Layer Visibility option for all layers, except for Layer 1.

This hides all layers, except Layer 1.

▲ Only Layer 1 is visible.

㉒ Select the Eraser Tool() from the toolbox. In the options bar, set Brush to **Hard Round** and Size to **20 pixels**.

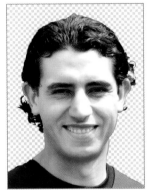 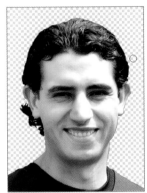

㉓ Drag over the edges of the image to erase any remnants of the background. Make sure that the Eraser Tool is not applied to the face.

㉔ Select the Background copy layer from the Layers palette.

㉕ Click the Set Foreground Color icon in the toolbox. In the Color Picker dialog box, set the RGB values to **210**, **240**, and **180**. Click OK. Next, set the RGB values for the background color to **0**, **150**, and **150**.

㉖ Select the Gradient Tool () from the toolbar. In the options bar, select **Linear Gradient** and set Opacity to **100%**.

㉗ Click and drag in a straight line from the top to the bottom to apply the gradient.

💡 Check that the Background copy layer is selected in the Layers palette before applying the gradient.

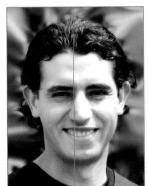 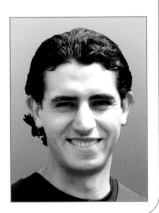

㉘ Next, we need to soften the edges of the face. Select Layer 1 from the Layers palette and click the image while holding down the Ctrl key to select the face.

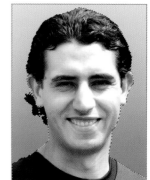

㉙ Select [Select]-[Modify]-[Contract] from the menu bar to shrink the selection border. In the Contract Selection dialog box, set Contract By to **3**. Click OK.

㉚ Select [Select]-[Feather] from the menu bar. In the Feather Selection dialog box, set Feather Radius to **5**. Click OK.

㉛ Select [Select]-[Inverse] from the menu bar to invert the contracted selection border.

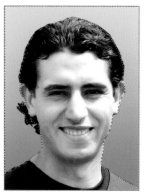

▲ Inverting the selection

32 Select [Select]-[Filter]-[Blur]-[Gaussian Blur] from the menu bar. The Feather Selection dialog box appears. Set Radius to **3**. Click OK.

This will blur the background.

33 Press Ctrl + D to deselect. In the Layers palette, drag Layer 1 onto the Create a New Layer button to make a copy of the layer.

34 Select the Layer 1 copy from the Layers palette. Select [Select]-[Filter]-[Blur]-[Gaussian Blur] from the menu bar. In the Gaussian Blur dialog box, set the Radius to **3** and click OK.

This will blur the man.

㉟ In the Layers palette, set Opacity to **40%** to soften the facial features.

▲ The final image

㊱ Select [File]-[Print Layouts]-[Picture Package] from the menu bar. Change the settings in the Picture Package dialog box as shown.

🔘 (tip) Try different combinations of the Page Size and Layout options until you get the picture package you want.

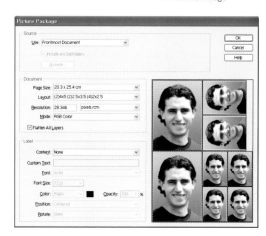

㊲ Click OK.

The result is a professional-looking picture package.

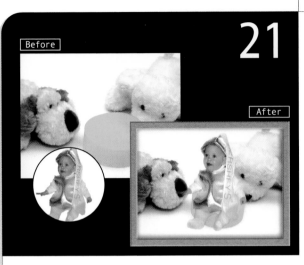

Before

After

Adding a Picture Frame

In this section, you will learn to combine an image of a baby with a picture of plush toys before framing it with one of the 15 default frames found in the Effects palette. You will adjust the contrast and feather the selection edges in order to blend the images together flawlessly. As you shall see, there are many interesting frames, from brushed aluminum to spatter, that you can choose from.

(1) Open the **Sample\Chapter 3\Tech21b.tif** file from the supplementary CD.

(2) Select the Magic Wand Tool () from the toolbox. In the options bar, check the **Contiguous** option and set Tolerance to **15**.

(3) Click on the image to select only the white background.

④ Press [Shift] + [Ctrl] + [I] to invert the selection and select the baby instead. Press [Ctrl] + [C] to make a copy of the baby.

⑤ Open the **Sample\Chapter 3\Tech21a.tif** file from the supplementary CD.

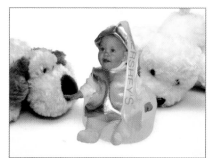

⑥ Press [Ctrl] + [V] to paste the copy onto the image.

⑦ Select [Image]-[Transform]-[Free Transform] from the menu bar or press [Ctrl] + [T]. The Free Transform bounding box will appear over the baby's image.

⑧ Place your cursor over a corner handle until it changes to a double-headed arrow. Hold down the [Shift] key and drag the handle outward to enlarge the image.

⑨ Drag the bounding box to position the baby on the yellow support. Press Enter to confirm the transformation.

⑩ Select [Enhance]-[Adjust Brightness/Contrast]-[Levels] from the menu bar or press Ctrl +L to adjust the contrast of the baby's image. In the Levels dialog box, enter the values **25**, **1.25**, and **235** in the Input Levels textboxes. Click OK.

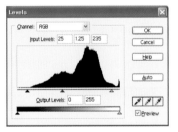

▲ The contrast in the baby's image now matches the background's.

⑪ In the Layers palette, hold down the Ctrl key and click on Layer 1 to select the baby.

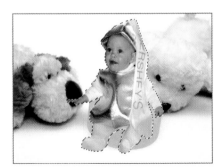

⑫ Choose [Select]-[Feather] from the menu bar. In the Feather Selection dialog box, set Feather Radius to **10** to soften the edges around the baby's image. Click OK.

▲ Before applying Feather

▲ After applying Feather

⑬ Invert the selection by pressing Shift + Ctrl + I . Press Delete to remove the border around the baby's image. Press Ctrl + D to deselect the baby.

⑭ Select [Window]-[Effects] from the menu bar. In the Effects palette, select **Frames** from the drop-down menu.

⑮ Click on the **Wood Frame** thumbnail. Then, click on the Apply button.

⑯ A warning box appears, asking if you wish to combine the layers into one. Click OK to create a picture frame around the image.

40 Digital Photo
Retouching Techniques

Editing Skills and Special Effects

In this chapter, you will learn all the essential editing skills for working with all kinds of images. You will learn to adjust image size and shape, remove elements from an image, combine images, and so on. This chapter also includes a number of sections on commonly used special effects such as adding reflections, inserting type and making type design, and creating zooming and spinning motion effects. By the end of the chapter, you will have mastered the skills and techniques necessary for most situations.

Chapter 4

Before

After

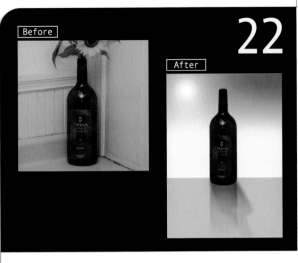

22 Adjusting Image Size and Shape

In this example, you will learn how to transform an ordinary product shot by using the Free Transform Tool to rotate, resize, and warp a copy of the image to add shadows. You will also use the Gradient Tool to create a background that has gradations in color and the Lens Flare filter to add a sparkle to the composition.

(1) Open the **Sample\Chapter 4\Tech22.tif** file from the supplementary CD.

(2) Select the Polygonal Lasso Tool () from the toolbox. Repeatedly click and drag along the bottle's shape to select it. When you have almost outlined the entire bottle, click on the point where you started to close the selection.

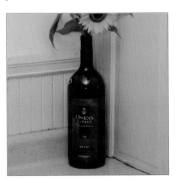

③ Double-click on the Background layer in the Layers palette to open the New Layer dialog box. The default Name is **Layer 0**. Click OK to change the Background layer into a regular layer.

④ Choose [Select]-[Inverse] from the menu bar to select the area around the bottle instead. Press Delete to remove the background.

⑤ Press Ctrl + D to deselect.

(tip) If you do not change the Background layer into a regular layer before deleting the selection, the deleted portion of the image will take the background color and will not be transparent.

⑥ Select [Image]-[Resize]-[Canvas Size] from the menu bar. In the Canvas Size dialog box, click the top center square in the Anchor grid. This will anchor the existing image to the top center position of the canvas. Set the Height to **20 cm**. Click OK.

⑦ Click and drag Layer 0 onto the Create A New Layer icon () in the Layers palette. This will create a Layer 0 Copy above Layer 0.

⑧ Select [Image]-[Transform]-[Free Transform] from the menu bar. The Free Transform bounding box appears around the bottle. In the options bar, set the angle to **-180°** to rotate the bottle by -180° counterclockwise.

(tip) You can also rotate the image with your mouse. After the bounding box appears, move your pointer near one of the corner handles until you see the pointer turn into [↗]. Then click and drag the corner to rotate the image.

⑨ Click and drag the rotated image downward so that its base lines up with the bottom of the original image.

(tip) A better way of creating a reflection is to use the [Image]-[Rotate]-[Flip Layer Vertical] command from the menu bar. This will flip the rotated image horizontally so that it looks exactly like a reflection of the original bottle. Although rotating the bottle is more troublesome and does not create an accurate reflection (the left side of the bottle is reflected on the right side), I want to get you familiar with the Free Transform Tool first.

(10) Move the pointer to the lower-middle handle of the reflec-
tion. The pointer changes to [↕]. Click and drag the bounding
box downward to make it longer. Hit [Enter].

(11) In the Layers palette, move Layer 0 Copy below Layer 0.
Click the Create a New Layer icon (⬛) in the Layers
palette to create a new layer. The new Layer 1 is created
above Layer 0 Copy.

(12) Click and drag Layer 1 right to the bottom of the layers.
Next, select the Rectangular Marquee Tool (⬚) from the
toolbox. Select the reflection, as shown.

(13) Click the Set Foreground Color icon in the toolbox. In the
Color Picker dialog box, set the RGB values to **140**, **200**, and
200. Click OK to change the foreground color.

⑭ Select [Edit]-[Fill] from the menu bar. In the Fill dialog box, set Use to **Foreground Color**. Click OK. Press Ctrl+D to deselect the selection.

⑮ Click the Create A New Layer icon () in the Layers palette to create a new layer. Click and drag the new Layer 2 below Layer 1.

⑯ Repeat steps 13 and 14 for Layer 2, using the RGB values **255**, **255**, and **200**, respectively.

(17) Select Layer 0 Copy in the Layers palette. Select [Filter]-[Blur]-[Motion Blur] from the menu bar to blur the reflection. In the Motion Blur dialog box, set Angle to **90°** and Distance to **250 pixels**. Click OK.

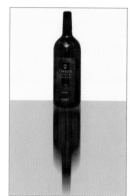

(18) In the Layers palette, set the Opacity of Layer 0 Copy to **50%** to lighten the reflection.

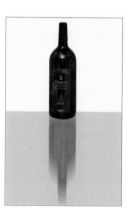

(19) Select the Eraser Tool () from the toolbox. In the options bar, set Brush to **Soft Round**, Size to **500 pixels**, and Opacity to **50%**. Click and drag over the reflection so that it gets fainter toward the bottom.

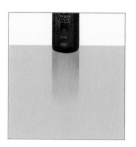

20 In the Layers palette, click and drag Layer 0 onto the Create A New Layer icon () to create a copy. Click and drag Layer 0 Copy 2 below Layer 0.

21 Select Layer 0 Copy 2. Select [Image]-[Transform]-[Free Transform] from the menu bar or press Ctrl+T. In the options bar, set Angle to **-180°** to rotate the bottle by 180° counterclockwise.

22 Drag the reflection downward so that its base lines up with the bottom of the bottle.

23 Hold down the Ctrl key and drag a lower-corner handle sideways. Repeat the step on the other corner until you get the result as shown. Press Enter.

24 Select the Move Tool () from the toolbox. Move the warped reflection so that its base lines up with the bottle.

25 Select [Filter]-[Blur]-[Gaussian Blur] from the menu bar. In the Gaussian Blur dialog box, set Radius to **15 pixels**. Click OK to blur the reflection.

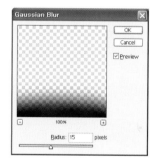

26 Select Layer 0 Copy 2. Select the Eraser Tool (). In the options bar, set Brush to **Soft Round**, Size to **500 pixels**, and Opacity to **50%**. Drag over the reflection such that it gets fainter toward the bottom.

27 Click the Set Foreground Color icon in the toolbox. In the Color Picker dialog box, set the RGB values to **160**, **90** and **0**. Click OK to change the foreground color.

28 Select Layer 2. Select the Gradient Tool () from the toolbox. In the options bar, click on the Gradient Picker arrow to see thumbnails of available gradients. Select the **Foreground to Transparent** gradient.

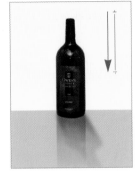

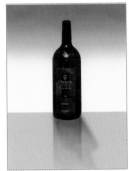

29 To apply the gradient to Layer 2, click and drag in the top-to-bottom direction, as shown.

30 Select [Filter]-[Render]-[Lens Flare] from the menu bar. In the Lens Flare dialog box, click and drag the crosshair in the preview window to the upper-left corner, as shown. Set the Brightness to **150%**. Click OK.

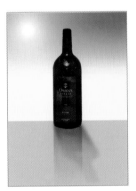

31 Select the Crop Tool () from the toolbox. Make the selection as shown. Press Enter to remove the unwanted areas.

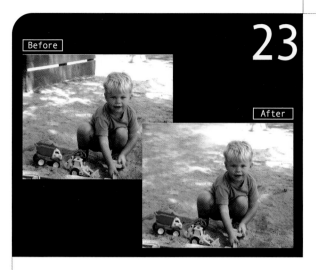

23 Cleaning Up Backgrounds

It is inevitable that unwanted people or objects will sometimes appear in the background of your pictures. This will ruin the composition of your shot and also detract attention from your main subject. As you learned in the example on removing facial blemishes, the Clone Stamp Tool can stamp out such unwanted objects easily. In this section, you will practice using the tool to clean up a background and also learn to use it in a perfectly straight line.

(1) Open the **Sample\Chapter 4\Tech23.tif** file from the supplementary CD. Note the many distracting objects in the background.

(2) Select the Clone Stamp Tool () from the toolbox. In the options bar, set Size to **50 pixels**, Mode to **Normal**, and Opacity to **100%**.

(3) Hold down the Alt key and click on a patch of clear ground near the toy truck and the stick on the right. This creates a copy of the ground as the clone.

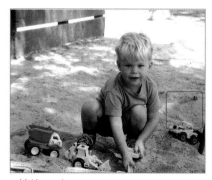

▲ Making a clone

④ Stamp over the toy truck and the stick to cover them up with the clone. Change your clone as you go along to avoid patchiness.

⑤ With the Clone Stamp Tool () selected, set the Size to **300 pixels** in the options bar.

⑥ Move the brush over the ground just below the railing to view the brush size.

Using the [Shift] Key for Straight Lines

If the object that you are trying to remove has a rather straight outline, like the smokestacks in the following example, you can use the [Shift] key together with the Clone Stamp Tool to remove it easily.

With the Clone Stamp Tool selected, simply hold down the [Shift] key and click on one end of the object. Then hold down the [Shift] key again and click on the other end. The Clone Stamp Tool will remove the area in-between in a straight line.

The following example can be found in the supplementary CD-ROM in the file named **Sample\ Chapter 4\Tech23-1.tif.**

- Set the Size of the Clone Stamp Tool to **200 pixels**. Hold down the [Shift] key and click on the tip of the smokestack.

- Hold down the [Shift] key and click on the smokestack's base.

- The Clone Stamp Tool applies the clone in a straight line between the starting and ending points.

(7) Hold down the [Alt] key and click on the ground to make a clone.

(8) Release the [Alt] key. Stamp on the wall to cover it up using the clone.

(9) Repeat the clone-and-stamp process a few times until the entire wall is removed.

▲ Making another clone using the [Alt] key

▲ Stamping over with the clone

▲ The cleaned-up image

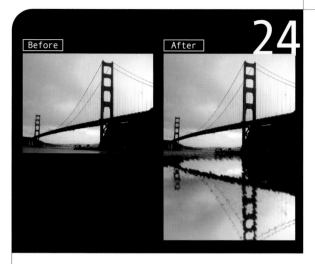

Before | After

24 Creating Reflections

When combining images, you may have to create a new reflection for the objects that you moved from the original image. Obviously, this is necessary only if there is a reflective element in your new composition. Even if you are not combining images, you may also want to create or retouch the reflections in your images to enhance the visual effect. In this example, my camera lens was not wide enough to take in the entire scene so I added the reflection later in Photoshop Elements.

① Open the **Sample\Chapter 4\Tech24.tif** file from the supplementary CD.

② Select [Image]-[Resize]-[Canvas Size] from the menu bar. In the Canvas Size dialog box, click on the top center square on the Anchor grid. This will anchor the image to the top center position of the canvas. Increase the Height to **20 cm**. Click OK.

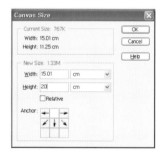

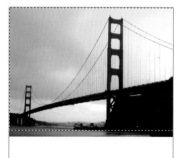

③ Select the Rectangular Marquee Tool () from the toolbox. Select the image, as shown here.

The extra space added to the canvas will take on the background color indicated at the bottom of the toolbox. For this exercise, use a white background color.

④ Select [Layer]-[New]-[Layer via Copy] from the menu bar to create a copy of the selection on a new layer. In the Layers palette, you can see that a new layer is created for the copy.

⑤ Select [Image]-[Rotate]-[Flip Layer Vertical] from the menu bar to flip the copy vertically.

⑥ Select the Move Tool () from the toolbox.

⑦ Drag the copy to the bottom of the original image to use it as the reflection.

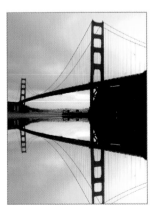

⑧ Select [Filter]-[Distort]-[Ripple] from the menu bar. In the Ripple dialog box, set Amount to **310%**. Click OK.

⑨ Select [Filter]-[Blur]-[Gaussian Blur] from the menu bar. In the Gaussian Blur dialog box, set Radius to **2 pixels** to blur the image slightly. This will make the reflection look more realistic. Click OK.

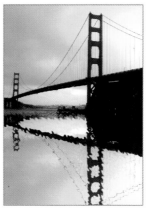

▲ Ripple ▲ Gaussian blur

⑩ Select the Burn Tool () from the toolbox. In the options bar, set Brush to **Soft Round**, Size to **250 pixels**, Range to **Midtones** and Exposure to **50%**.

⑪ Drag over the reflection to make it darker.

Adding Type Effects

In this section, you will learn to enhance the visual appeal of text on images by a series of blending, warping, and embossing. In this exercise, we will emboss a word onto a curved surface to make it look like it is actually part of the surface.

① Open the **Sample\Chapter 4\Tech25.jpg** file from the supplementary CD.

② Select the Horizontal Type Tool (T) from the toolbox. In the options bar, set Font to **Arial Black**, Size to **60 points**, and Color to **Black**.

③ Click on the orange sled in the picture, and type in the word **Elements.**

④ Select [Layer]-[Type]-[Warp Text] from the menu bar. In the Warp Text dialog box, set the Style to ☐ Arc , Bend to **-25%**, Horizontal Distortion to **0%**, and Vertical Distortion to **-15%**. Click OK.

⑤ Press `Ctrl`+`T` to activate the Free Transform command. When the bounding box appears, move the pointer near one of the corner handles. When the pointer changes to ↘, click and drag the box until it fits the shape of the sled. Hit `Enter`.

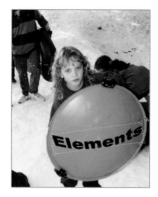

⑥ Select [Window]-[Effects] from the menu bar. When the Effects palette appears, select **Text Effects** and double-click on the **Clear Emboss** effect, which will make the text looks as if it is protruding from the sled. Click Apply.

 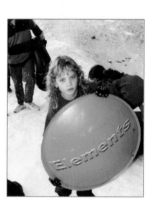

Ⓥ Fine-tuning the Effects Applied

You can fine-tune the effects you have already applied by double-clicking the ⊘ symbol next to the layer to which the effects were applied. This opens up the Style Settings dialog box from which you can adjust factors such as the lighting angle, bevel size, and direction.

You can also select [Layer]-[Layer Style]-[Style Settings] from the menu bar to open the Style Settings dialog box.

26 Merging Text and Images

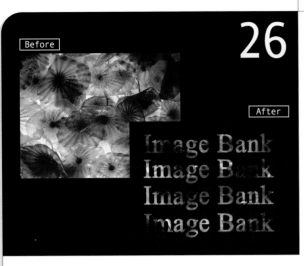

When working with text and images, you have to think of type as a design element. You can create many type designs in Photoshop Elements with the [Layer]-[Type] command, which you tried out in the last section, but there are many other ways of creating unusual text effects. In this section, you will group a text layer and an image layer to get the effect of a text cut out from an image.

① Open the **Sample\Chapter 4\Tech26.tif** file from the supplementary CD.

② Select the Horizontal Type Tool (T) from the toolbox. In the options bar, set Font to **Times New Roman**, Size to **90 pt**, and select **Faux Bold(T)**.

③ Type in the words **Image Bank**. When you are done, click the Commit Any Current Edits button(✓) in the options bar or select another tool to continue.

> In the Layers palette, you can see that a new text layer named Image Bank is automatically created.

④ Right-click on the Image Bank text layer and select [Simplify Layer] to change it into a normal layer.

⑤ Select the Move Tool (🖰) from the toolbox. Hold down the [Alt]+[Shift] keys and drag the text to the bottom, as shown. This creates a copy of the text on a new layer.

💡 The [Alt] key copies the image, while the [Shift] key restricts the image to vertical and horizontal movements.

⑥ Repeat the step to make another two copies of the text. In Layers palette, you can see that the text and its copies are on four different layers.

⑦ Click on the Indicates If Layer Is Linked box next to these layers. A link symbol () will appear next to the layer to indicate that they are linked.

⑧ Click the More button at the upper right corner of the Layers palette and select [Merge Linked] from the drop-down menu. This will combine the layers with text.

All of the text is on one layer now ▶

⑨ Double-click on the Background layer in the Layers palette. In the New Layer dialog box, you can see that the default name is Layer 0. Click OK to change the Background layer into a regular layer.

(tip) As a Background layer has to remain right at the bottom of the Layers palette, we changed it into a regular layer so that we can change its stacking order.

⑩ Click and drag the layer with text below Layer 0. The colorful image is now on top of the text.

⑪ Hold down the Alt key and click on the line between the two layers to group them together. In the Layers palette, you can see that a Grouped Layer icon() has appeared beside the overlying image layer. You may also notice that the name of the underlying text layer has been underlined.

Grouping the layers ▶

(12) On screen, you will see the text cut out from the image. The rest of the image is not visible.

(tip) When layers are grouped, the bottommost layer or base layer defines the visible areas for the entire group.

(13) Select the Layer 0 from the Layers palette. Click the Create a New Layer icon (). This will create a new layer above Layer 0.

(14) Set the foreground color to black in the toolbox. Press Alt + Delete to apply the Fill command. This will color the new layer black.

(15) Click and drag Layer 1 to the bottom to create a black background for the image.

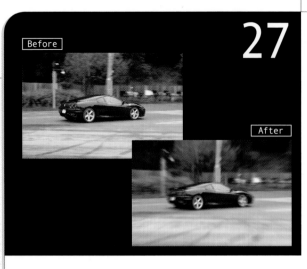

Before

After

27 Zooming

You can make your pictures more dynamic by using the Radial Blur filter on the menu bar. The Zoom blur method found on the filter is particularly useful. You can use it on all sorts of pictures to imitate the effect of a zooming lens.

(1) Open the **Sample\Chapter 4\ Tech27.jpg** file from the supplementary CD.

(2) Select [Filter]-[Blur]-[Radial Blur] from the menu bar. In the Radial Blur dialog box, set Amount to **20**, Blur Method to **Zoom**, and Quality to **Good**.

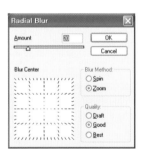

(tip) In the Blur Center window, you can see that the default is in the center, which is just what we need for this photo. If you need to fix the blur center somewhere else, just click in the Blur Center window.

(3) Click OK to apply the filter.

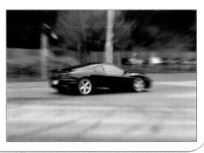

28 Spinning

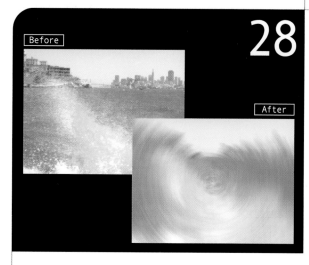

Before

After

Other than the zooming effect, you can create a spinning effect using the Radial Blur filter. In this section, you will learn to make ocean waves appear to be spinning rapidly.

① Open the **Sample\Chapter 4\ Tech28.jpg** file from the supplementary CD.

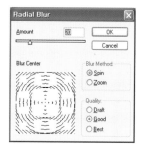

② Select [Filter]-[Blur]-[Radial Blur] from the menu bar. In the Radial Blur dialog box, set the Amount to **20**, Blur Method to **Spin**, and Quality to **Good**.

③ Click OK to apply the spinning effect to the image.

(tip) Applying the Zoom effect to this picture will make the waves appear to be coming at you.

▲ Spinning effect

▲ Zooming effect

29 Combining Images

| Before |

| After |

One of the easiest ways to create new and exciting compositions is to combine individual pictures. In this section, you will learn to combine images inconspicuously by cleaning up the edges of pasted objects and adjusting the brightness and contrast.

① Open the **Sample\Chapter 4\Tech29a.tif** file from the supplementary CD.

② Select the Zoom Tool (🔍) from the toolbox. Select the man on the left to zoom in on him.

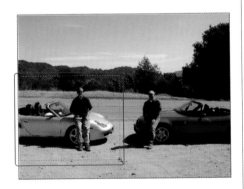

③ Select the Selection Brush Tool (✏) from the toolbox. In the options bar, set Size to **35 pixels**, Mode to **Mask**, Hardness to **0%**, Overlay Opacity to **50%**, and Overlay Color to **Red**.

🔖 A Hardness of 0% makes the brush edges soft and natural. This is important in making the selection border less obvious when the image is placed into another picture.

④ Paint over the man, the silver car, and their shadows to create a mask. Change your brush size as you go along in order to cover accurately.

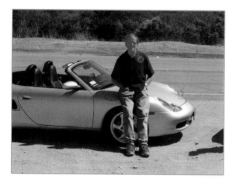

⑤ In the options bar, set the Mode to **Selection**. This will select the unmasked area.

⑥ Choose [Select]-[Inverse] from the menu bar to invert the selection and select the masked area instead. Press Ctrl + C to copy the selection.

⑦ Open the **Sample\Chapter 4\Tech29b.tif** file from the supplementary CD.

⑧ Press Ctrl+V to paste the image of the man and his car onto the image of the beach.

⑨ Select the Move Tool (⊹) from the toolbox. Drag the man and his car to the position, as shown.

⑩ Select the Zoom Tool (🔍) from the toolbox. Select the car to zoom in on it.

⑪ Select the Eraser Tool (✐) from the toolbox. In the options bar, set the Brush to **Soft Round** and Size to **9 pixels**. Use the Eraser Tool to clean up the edges of the pasted image.

⑫ In the options bar, set Size to **50 pixels** and Opacity to **50%**. Use the Eraser Tool to clean up the edges of the car's shadow.

⑬ Let's adjust the brightness and contrast of the pasted image to match the background's. Select [Enhance]-[Adjust Brightness/ Contrast]-[Brightness/Contrast] from the menu bar. In the Brightness/Contrast dialog box, set Brightness to **5** and Contrast to **10**. Click OK.

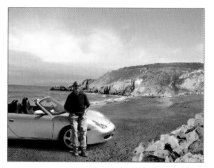

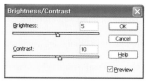

⑭ Click the More button in the Layers palette. Select [Flatten Image] from the drop-down menu to combine the two images on one layer.

⑮ Select [Filter]-[Render]-[Lens Flare] from the menu bar. In the [Lens Flare] dialog box, click in the Flare Center window to position the lens flare. Set Brightness to **100%**. Click OK.

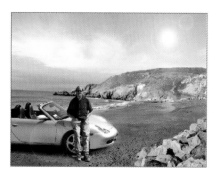

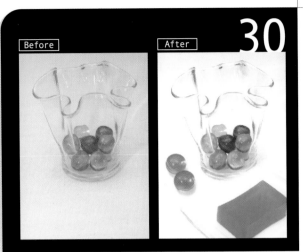

Before After

30 Combining Product Pictures

Product shots are some of the most popular assignments for professional photographers. If after a product shoot, you find that you are dissatisfied with the composition of the shots you took, you can consider combining several individual product shots on a single page for the result you want. Sometimes you need to do this because there is neither time nor opportunity to reshoot the pictures.

① Open the **Sample\Chapter 4\Tech30a.tif** file from the supplementary CD.

② Select [Enhance]-[Adjust Brightness/Contrast]-[Brightness/Contrast] from the menu bar. In the Brightness/Contrast dialog box, set Brightness to **+15** and Contrast to **+25**. Click OK. This will make the image brighter.

③ Double-click on the Background layer in the Layers palette. When the New Layer dialog box appears, you will see that the default file name is Layer 0. Click OK. The Background layer will be turned into an ordinary layer.

④ Open the **Sample\Chapter 4\Tech30b.tif** file from the supplementary CD.

⑤ Select the Move Tool () from the toolbox. Drag the bar soap image over to the bubble soap image, as shown.

⑥ Close the bar soap file. In the bubble soap window, drag the soap dish below the container, as shown.

⑦ Select the Eraser Tool () from the toolbox. In the options bar, set Size to **150 pixels** and Opacity to **100%**. Erase the area around the soap dish, as shown.

⑧ Open the **Sample\Chapter 4\Tech30c.tif** file from the supplementary CD.

⑨ Select the Elliptical Marquee Tool () from the toolbox. Click and drag over a bubble soap to select it.

⑩ Click on the Add To Selection icon (▣) on the options bar. Select another bubble soap to add it to the selection.

⑪ Select the Move Tool (�,+) from the toolbox. Drag the bubble soap over to the main image, as shown. The bubble soap will be added on the new Layer 2.

⑫ Close the **Tech30c.tif** file. In the Layers palette, drag Layer 2 onto the Create A New Layer icon (▣) to make a copy of the bubble soap.

(13) Move Layer 2 Copy below Layer 2.

(14) Select [Filter]-[Blur]-[Gaussian Blur] from the menu bar. In the Gaussian Blur dialog box, set Radius to **5 pixels**. Click OK to blur the edges of the bubble soap slightly.

(15) In the Layers palette, set Opacity for Layer 2 Copy to **70%**. We will use this image as the shadow for the bubble soap.

(16) Select the Move Tool () from the toolbox. Press the ↓ and ↑ keys on the keyboard several times to move the shadow to the lower right of the bubble soap.

(17) Select [Enhance]-[Adjust Brightness/Contrast]-[Levels] from the menu bar. In the Levels dialog box, enter **0**, **1.5**, and **255** in the Input Levels text boxes to brighten up the shadow, as shown. Click OK.

(18) Select Layer 2 from the Layers palette. Select [Filter]-[Blur]-[Gaussian Blur] from the menu bar. In the Gaussian Blur dialog box, set Radius to **1pixel**. Click OK. The blurring will blend the edges of the bubble soap into the background.

(19) Press Ctrl + 0 to see the entire image. Check that the brightness and contrast is even throughout. If it is not, make adjustments using the [Enhance]-[Adjust Brightness/Contrast]-[Levels] or [Enhance]-[Adjust Brightness/Contrast]- [Brightness/Contrast] commands.

31 Stitching Panoramas

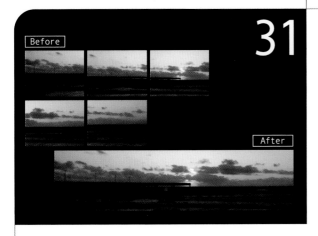

It is difficult to capture the wide expanse of a landscape in a single picture. If you stand some distance away in order to get everything in, the elements of the scene will appear too small. If you stand too close, the reverse happens. For such scenes, it is better to capture sections of the landscape in a few shots and then merge them together in Photoshop Elements.

(1) Select [File]-[Create Photomerge] from the menu bar. In the Photomerge dialog box, click [Browse].

(2) When the Open dialog box appears, open the **Sample\ Chapter 4\panorama** folder in the supplementary CD drive. Hold down the Shift key and select all the pictures in the folder.

(3) Click [Open]. The files will appear in the Source Files window in the Photomerge dialog box.

④ Click OK to open the files and execute the Photomerge command. The program will automatically analyze the image data of the overlapping areas between the pictures and merge the pictures into a panorama. Note that the center piece is in the wrong position.

⑤ Click on the Select Image Tool () in the Photomerge dialog box. Click and drag the center image to the right.

⑥ Check the Advanced Blending option under Composition Settings on the right of the [Photomerge] dialog box to blend the edges of the pictures. Click [Preview].

⑦ Click OK to complete the photomerge. The panorama appears in a new window.

⑧ Select the Crop Tool (⊡) from the toolbox. Select the image, leaving out jagged edges. Press Enter .

40 Digital Photo
Retouching Techniques

Very Special Effects

One feature that instantly attracts many beginners to Photoshop Elements is the Filter command. As you discovered in the previous chapters, you can create dozens, if not hundreds, of snazzy effects with this command.

In this chapter, you will explore the filters further and learn to make practical and creative use of these filters together with other commands. The examples I am about to show you are wide and varied. You will learn to imitate photography techniques such as selective focusing and motion blur, enhance landscape pictures by casting a fog or making it snow, utilize the Define Pattern command, and do much, much more.

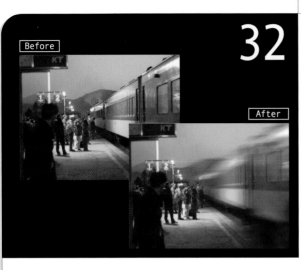

Before

After

32 Adding Motion Blur

The Motion Blur filter in Photoshop Elements is great for adding motion to pictures of movable objects. It is commonly used on images of vehicles such as cars and trains. You can also use it on a shot of people walking or even on a shot of a fan.

(1) Open the **Sample\Chapter 5\Tech32.tif** file from the supplementary CD.

(2) In the Layers palette, click and drag the Background layer onto the Create A New Layer button to make a copy of the layer. In the following steps, we will be adding motion blur effects to the copy and overlaying it on the background.

(3) Select [Filter]-[Blur]-[Motion Blur] from the menu bar. In the Motion Blur dialog box, set Angle to **5°** and Distance to **100 pixels**. Click OK.

(V) Angle refers to the direction in which the motion blur will be applied. An angle of 0° applies the motion blur horizontally and an angle of 90°, vertically. In this example, an angle of 5° applies the motion blur at a slight angle from the x-axis. Distance refers to how far the motion blur is applied.

④ Select the Eraser Tool () from the toolbox. In the options bar, set Size to **300 pixels**. Erase everything in the picture but the train. This allows the background to show through areas that we want to keep in focus.

⑤ In the options bar, set Opacity to **30%**. Drag over the front portion of the train to reduce the motion blur. This gives the image an illusion of depth.

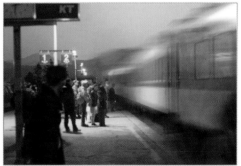

33 Selective Focusing

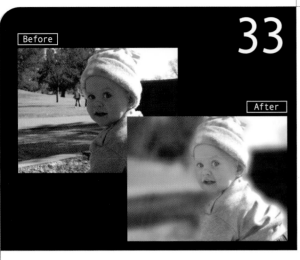

Before

After

Selective focusing is the photographic technique of keeping an area of the scene in focus while the rest of the scene is blurred. This technique has the effect of focusing the viewer's attention on a particular object or area of the image. If you are not using an SLR camera, this effect can be hard to create because the scene in your viewfinder will always look sharp. With Photoshop Elements, however, you can create such effects without the need for special lenses or equipment.

(1) Open the **Sample\Chapter 5\Tech33.jpg** file from the supplementary CD.

As you can see from the picture, the sun is behind the baby, leaving it in the shadows.
You must, therefore, first brighten the baby up before creating the selective focusing effect.

(2) Pick the Selection Brush Tool () from the toolbox. Set Brush to **Soft Round**, Size to **85 pixels**, Mode to **Selection**, and Hardness to **0%**. Brush over the darker areas of the baby to select it as shown here.

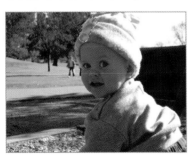

③ Select the Dodge Tool (placeholder) from the toolbox. Set Brush to **Soft Round**, Size to **170 pixels**, Range to **Midtones**, and Exposure to **50%**. Click and drag over the baby to brighten it up.

④ Now, in order to create the selective focusing effect, you need to select the entire baby. Pick the Selection Brush Tool (). Set Brush to **Soft Round**, Size to **200 pixels**, Mode to **Selection**, and Hardness to **0%**. Brush over the previously unselected parts of the baby to add them to the selection.

⑤ In the options bar, set Size to **20 pixels**. The smaller brush size allows you to select the edges more precisely.

⑥ Choose [Select]-[Save Selection] from the menu bar. In the Save Selection dialog box, enter **baby** in the Name field. Click OK to save the selection for later use. Press Ctrl + D to deselect.

Ⓥ **Modifying a Selection**

If you want to remove an area from a selection, hold down the Alt key and drag over it.

⑦ In the Layers palette, drag the Background layer onto the Create A New Layer button to make a copy.

⑧ Select [Filter]-[Blur]-[Gaussian Blur] from the menu bar. In the Gaussian Blur dialog box, set Radius to **30 pixels**. Click OK to blur the copy.

⑨ Choose [Select]-[Load Selection] from the menu bar. In the Load Selection dialog box, select **baby** from the Selection drop-down menu. Click OK to load the selection border.

⑩ Choose [Select]-[Modify]-[Contract] from the menu bar. In the Contract Selection dialog box, set Contract By to **5 pixels**. Click OK to shrink the selection border by **5 pixels**.

(tip) As you will see later, shrinking the selection border helps to soften the border between the image and the background.

⑪ Press Delete to remove the selection. The sharp image of the baby on the Background layer will show through the blurred copy, thus creating a selective focusing effect. Press Ctrl + D to deselect.

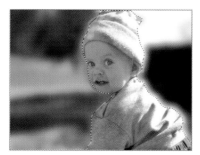

34 Casting a Fog

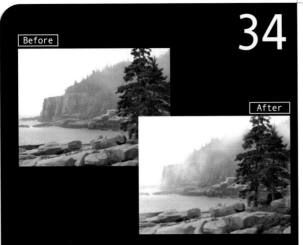

Imagine a river at dawn, with fog cloaking the water edges. Fog can add such a sense of mystique and charm to pictures, but opportunities to photograph such images are rare. In this section, you will learn how to add fog effects on an ordinary picture and conjure up a very different mood.

① Open the **Sample\Chapter 5\Tech34.tif** file from the supplementary CD.

② Click on the Create A New Layer icon () in the Layers palette to create a layer for the fog effect.

(tip) By using a new layer for the fog effect, you can leave the original image intact.

③ Click on the Layer 1 name and change it to **Fog**.

④ Click on the Switch Foreground And Background Colors icon(⤡) at the bottom of the toolbox to set the foreground color to black and the background color to white.

⑤ Select [Filter]-[Render]-[Clouds] from the menu bar. The filter will be immediately applied to the layer.

🔵 You can change the color of the fog or clouds by changing the foreground and background colors, as shown here.

⑥ In the Layers palette, set the Blending Mode to **Screen**. This will create a fog over the image, but its evenness makes it look artificial.

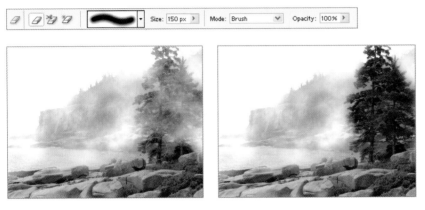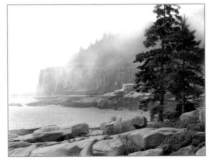⑦ Select the Eraser Tool () from the toolbox. In the options bar, set Brush to **Soft Round**, Size to **150 pixels**, Mode to **Brush**, and Opacity to **100%**. Erase the fog from nearby objects, such as rocks and trees, to make it less even and look more realistic.

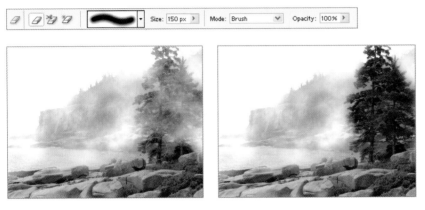

(tip) Check that the Fog layer is selected in the Layers palette before making any changes to the fog effects.

⑧ Set Opacity to **30%** on the options bar. Lightly erase the fog in the center and lower parts of the picture.

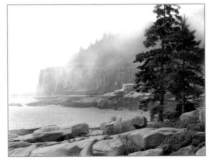

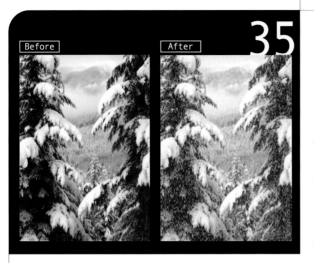

Before | After

35 Let It Snow

Taking pictures in subzero temperatures is hard, but getting a shot with just the right amount of snowfall is even more difficult. You need perseverance and luck to get those kinds of shots. In this section, you will make a picture of snow-capped trees and mountains even more perfect by adding a snowfall with the Add Noise filter.

1 Open the **Sample\Chapter 5\Tech35.tif** file from the supplementary CD.

2 Click the Create A New Layer icon () in the Layers palette to create a new layer for the snow effect.

3 Select the Rectangular Marquee Tool () from the toolbox. Make the selection, as shown here.

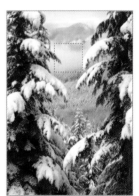

④ Click on the Set Background Color icon in the toolbox and set the background color to black. Select [Edit]-[Fill] from the menu bar. In the Fill dialog box, set Use to **Background Color**. Click OK to fill the selection with black.

⑤ Select [Filter]-[Noise]-[Add Noise] from the menu bar. In the Add Noise dialog box, set Amount to **40%** and Distribution to **Gaussian**, and click the **Monochromatic** checkbox to create the effect in black and white. Click OK.

> The white noise added to the picture looks like falling snow. You can increase the volume of snow by increasing the Amount in the Add Noise dialog box. Do not apply too much because it will look unnatural.

⑥ Select [Image]-[Transform]-[Free Transform] from the menu bar. A bounding box will appear around the snowflakes. Click and drag the corner handles of the bounding box so that its height fits the image's, but its width is slightly shorter. Press `Enter` to apply the changes

> Adjusting the height of the selection elongates the snowflakes which would appear round otherwise.

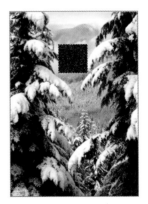

⑦ Select [Edit]-[Define Pattern] from the menu bar to save the snowflakes as a pattern. In the Pattern Name dialog box, type in **Snow** for Name. Click OK.

💡 You should save a pattern if you intend to apply it repeatedly.

⑧ Press [Ctrl]+[D] to deselect the selection. Select [Edit]-[Fill] from the menu bar. In the Fill dialog box, set Use to **Pattern**. Click the Custom Pattern icon to open the Pattern Picker. Choose the Snow pattern.

⑨ Click OK to apply the snow pattern to the entire image.

⑩ In the Layers palette, set the Blending Mode to **Screen** to let the background image show through.

Ⓥ **Creating Snow Using the Effects Palette**
Although it is easier to create snow using the Effects palette, you cannot adjust the shape or amount of snow with this method. To try it out, select [Window]-[Effects] from the menu bar to open the Effects palette. Then select Blizzard and click [Apply].

36 Creating TV Scan Lines with Patterns

Before

After

If you look closely at your TV screen, you will notice that there are very thin horizontal lines on the screen. These are actually lines of pixels, and they are called scan lines. Computer monitors and TV screens refresh their image scan line by line. Adding these lines to images will make them look as if they are taken from a TV screen.

(1) Select [File]-[New] from the menu bar. In the New dialog box, set Width to **0.4 cm**, Height to **0.4 cm**, and Resolution to **72 pixels/inch**. Click OK.

(2) Because the image is too small to work with on the screen, we need to magnify it. Select [Window]-[Navigator] from the menu bar. In the Navigator palette, click on the Zoom In button () at the lower right corner of the palette until the image is magnified at **1600%**.

(3) Select the Rectangular Marquee Tool () from the toolbox. Select half of the image, as shown.

④ Click on the Default Foreground and Background Colors icon (▉) in the toolbox to set the foreground color to black. Select the Paint Bucket Tool (⟐) from the toolbox. Click on the selection to color it black.

> The black area will be used as scan lines, while the white area is actually transparent, allowing the image to show through. In addition, the size of the black-and-white areas is uniform to create a realistic scan line effect.

⑤ Select [Select]-[All] from the menu bar to select the entire image.

⑥ Select [Edit]-[Define Pattern] from the menu bar. In the Pattern Name dialog box, type in **Pattern 1** for Name. Click OK.

⑦ Open the **Sample\Chapter 5\Tech36.jpg** file from the supplementary CD.

⑧ Select [Window]-[Layers] from the menu bar. In the Layers palette, click on the Create A New Layer icon (⬚) in the Layers palette to create a layer for the scan lines.

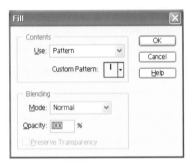

⑨ Click on the new layer to select it. Select [Edit]-[Fill] from the menu bar. In the Fill dialog box, set Use to Pattern and Custom **Pattern** to ⬚. Click OK to apply the pattern repeatedly to Layer 1 to create scan lines.

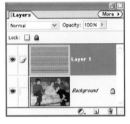

⑩ In the Layers palette, change the Blending Mode from Normal to **Overlay** to let the background layer show through.

⑪ In the Layers palette, set Opacity to **10%** to make the scan lines less obvious and more realistic-looking.

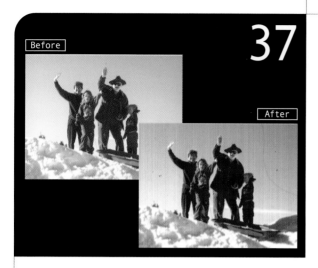

37 Antiquing Pictures

Old photographs evoke nostalgia and seem more precious because of their fragility and the fact that the memories they capture are of a distant past. You can imitate the faded look of antiquated photos in your images by desaturating the colors, adding hair and dust particles, and blending the effects together in Photoshop Elements.

① Open the **Sample\Chapter 5\Tech37.jpg** file from the supplementary CD.

② Select [Filter]-[Texture]-[Grain] from the menu bar. In the Grain dialog box, set Intensity to **12**, Contrast to **13**, and Grain Type to **Vertical**. Click OK to add fine vertical lines and a grainy texture to the picture. This will make the family portrait look as if it had been shot with an old camera.

⊙ If you want to add **horizontal** lines instead of vertical ones, set Grain Type to Horizontal in the Grain dialog box.

③ Select [Enhance]-[Adjust Color]-[Hue/Saturation] from the menu bar. In the Hue/Saturation dialog box, set Edit to **Master**, Hue to **-20**, Saturation to **-50**, and Lightness to **0**. Click OK. This will make the colors look faded.

④ Select [Window]-[Effects] from the menu bar. When the Effects palette appears, double-click on the Vertical Color Fade effect. The colors in the family portrait will fade toward the top.

(tip) You can make the color fade across a picture by selecting the Horizontal Color Fade icon in the Effects palette.

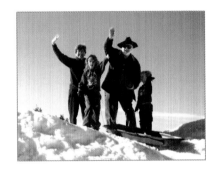

⑤ Open the **Sample\Chapter 5\Tech37a.jpg** file from the supplementary CD. This image was created by scanning the hair and dust particles placed on a scanner.

⑥ Press Ctrl+A to select the entire image and then press Ctrl+C to copy it.

⑦ Return to the family portrait and press Ctrl+V to paste the dust copy onto it.

⑧ Press Ctrl+T and expand the dust image to fit the size of the picture. Press Enter or double-click inside the image when you are done.

⑨ In the Layers palette, change the Blending Mode of Layer 1 to **Multiply**. This will allow the family portrait to show through the dust copy.

Before

After

38 Creating Neon Light Images

The most mesmerizing and attention-grabbing signs are probably found in neon-lit cities like glitzy Las Vegas. With Photoshop Elements, you can create the same colorful, neon-like effects using filters and a variety of blending modes.

① Open the **Sample\Chapter 5\Tech38.psd** file from the supplementary CD. Note that the background and the bicycle are on separate layers.

Because bright neon colors look better against a dark background, the background color in this example has been set to black.

② Select Layer 1 from the Layers palette. Select [Layer]-[Duplicate Layer] from the menu bar. In the Duplicate Layer dialog box, type in **Neon** in the As text box. Click OK to add a copy named Neon.

③ Hold down the `Ctrl` key and click the Neon layer in the Layers palette to load it as a selection border in the image.

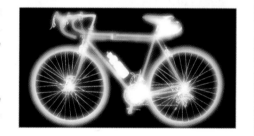

④ Change the foreground color to white. Select [Edit]-[Fill] from the menu bar. In the Fill dialog box, set Use to **Foreground Color**. Click OK to color the bicycle white. Press `Ctrl`+`D` to deselect the bicycle.

⑤ Select [Filter]-[Blur]-[Gaussian Blur] from the menu bar. In the [Gaussian Blur] dialog box, set Radius to **10 pixels**. Click OK. The image will look very bright and luminous.

⑥ Drag the Neon layer below Layer 1. The bicycle now glows around the edges.

⑦ Click and drag the Neon layer onto the Create A New Layer icon () to make a copy. The new Neon Copy is added above the Neon layer. This increases the intensity of the glow.

⑧ Select [Filter]-[Motion Blur] from the menu bar. In the Motion Blur dialog box, set Angle to **30°** and Distance to **270 pixels**. Click OK. This will make the image look more dynamic.

⑨ Click the Create A New Layer icon () in the Layers palette to add a new layer. Click on the name of the new layer and type in **Gradient**.

⑩ Select the Gradient Tool () from the toolbox. In the options bar, set Gradient to **Spectrum** and Type to **Radial**. Set the other options as shown.

⑪ Hold down the [Shift] key and drag across the image from left to right, as shown. This creates concentric bands of colors on the Gradient layer.

🔘 Holding down the [Shift] key enables you to apply the gradient vertically, horizontally, or diagonally.

⑫ In the Layers palette, change the Blending Mode of the Gradient layer to **Color**. This will apply the gradient to the white and gray regions of the image and not the black areas.

 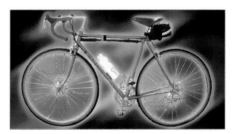

⑬ Select Layer 1 from the Layers palette. Change the Blending Mode to **Linear Dodge**. This will brighten both the bicycle and the gradient color.

 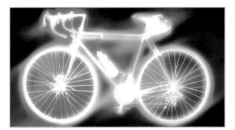

40 Digital Photo
Retouching Techniques

Preparing for the Web

In this chapter, you will learn to design a web banner using commands such as Photomerge and Gradient Map. You will also learn to create a web photo gallery to share your images on the Internet. While this may seem daunting to beginners, it really isn't. The Create Web Photo Gallery command automates so many of the steps that creating an online gallery is almost like shopping.

39 Making a Web Banner

You can use Photoshop Elements to create images that are optimized for the Web and use those images as part of a website such as a web banner. In this section, you will learn to use the Gradient Map command together with the Photomerge command in making a web banner.

(1) Select [File]-[Create Photomerge] from the menu bar. When the Photomerge dialog box appears, click [Browse].

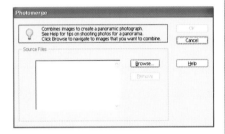

(2) Select the **Sample\Chapter 6\banner** folder on the supplementary CD. Hold down the [Shift] key and click each of the pictures in the folder to select all of them. Click [Open]. This will add the selected pictures to the Photomerge dialog box.

(3) Click OK. A warning message saying that Photomerge is unable to merge the images to form a panorama appears. Click OK to close the message box.

(tip) When using Photomerge to make panoramas, the source images must have overlaps of 15%-40% of the image areas. Otherwise, Photomerge may not be able to assemble the images. When making a web banner, the images to be merged may be entirely different and Photomerge cannot automatically align them. You have to manually arrange the images instead.

Chapter 6

④ In the Photomerge dialog box, drag an image from the lightbox on to the work area, as shown. The overlapping edge between the images is blended automatically.

⑤ Repeat step 4 on all the other images on the lightbox. Remember to position them with the edges overlapping, as shown.

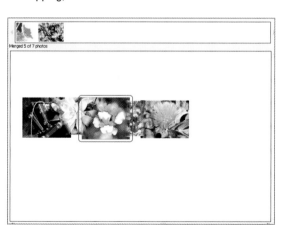

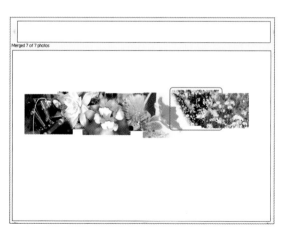

💡 To blend edges seamlessly, you need to move the image around until you find the perfect position.

(6) Check the Advanced Blending option under Composite Settings on the right of the Photomerge dialog box. Click [Preview].

(tip) If you are not satisfied with the panorama, click the [Exit Preview] button and reposition the images.

(7) Click OK to merge the photos. The panorama will appear in a new window.

(8) Select the Crop Tool () from the toolbox. Set Width to **468 pixels**, Height to **60 pixels**, and Resolution to **72 pixels/inch**.

(tip) The Crop tool's default unit of measurement for width and height is centimeters. If you type **468**, it will be interpreted as **468 cm**. To use a different unit of measurement, you need to include the unit as well, i.e. **468 pixels**.

(9) Select the part of the image to be used as the web banner. Hit [Enter] to crop off the unwanted areas.

⑩ Select [Layer]-[Duplicate Layer] from the menu bar. When the Duplicate Layer dialog box appears, click OK to make a copy.

⑪ Click the Create New Fill Or Adjustment Layer button (⬛) in the Layers palette and select Gradient Map. In the Gradient Map dialog box, click on the arrow to open the Gradient Picker and click the Black, White square.

⑫ Click OK. A black-and-white gradient map is created.

💡 The Gradient Map command takes the tonal range of an image and maps it to the colors of the gradient you choose. In this example, the gradient map is in black and white.

⑬ Select the Rectangular Marquee Tool (⬛) from the toolbox. Make the selection, as shown here.

⑭ Choose [Select]-[Feather] from the menu bar. In the Feather Selection dialog box, set Feather Radius to **100 pixels**. Click OK to soften the edges of the selection.

⑮ Press [Delete] to remove the gradient map and reveal the color image in the selection. Press [Ctrl]+[D] to deselect.

🔘 If you do not apply feathering to the selection border, the edges will be distinct without a gradual transition between the colored and black-and-white sections of the image.

⑯ Select the Horizontal Type Tool ([T]) from the toolbox. In the options bar, set Font to **Franklin Gothic Medium** and Size to **40 pt**.

⑰ Click the Set The Text Color swatch in the options bar. When the Color Picker dialog box appears, click the Only Web Colors checkbox. This ensures that the web banner uses only web-safe colors or colors that will display accurately on computer screens. Set the hexadecimal color value to **99FF00**.

⑱ Complete the web banner by typing in the text as shown.

⑲ Select [File]-[Save For Web] from the menu bar and save the image as a .gif or .jpg file.

sunset_blue.jpg

40 Making a Web Photo Gallery

These days, most professional photographers have a web photo gallery where they display their pictures on the Internet. A web photo gallery is a simple website consisting of a home page with thumbnails of images that you can click to see full-sized images. In Photoshop Elements, creating a web photo gallery is very simple. You will only need to enter some information and make some selections, and the program will do the rest for you.

① Select [File]-[Create Web Photo Gallery] from the menu bar. When the Web Photo Gallery dialog box appears, select the **Horizontal Dark** web gallery style from the Styles drop-down menu. Type your e-mail address in the E-mail field.

② Click [Browse]. When the Browse For Folder dialog box appears, select the **Sample\Chapter 6\Web** folder from the supplementary CD. Click OK. The images in the folder have been selected as the photos for the web photo gallery.

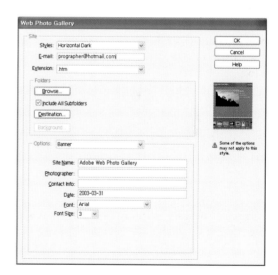

③ Click [Destination]. When the Browse For Folder dialog box appears, select a folder or click [Make New Folder] to create a new folder for the web photo gallery images and files. Click OK.

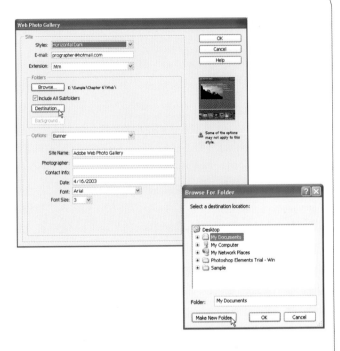

④ Type in the name of the photo gallery in the Site Name text box and enter your name in the Photographer textbox. Click OK to create the gallery.

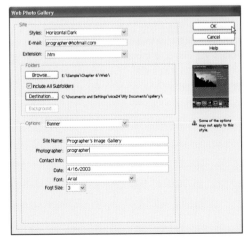

⑤ The following files will be created in the destination folder:

- An index.htm file that contains your homepage. Open this in a web browser to preview the gallery.
- JPEG images
- HTML pages
- JPEG thumbnails
- Other files for the gallery style

⑥ After the conversion is complete, the web browser opens to show the photo gallery web page. You can move the slider bar at the bottom to browse through the thumbnails. To view an image, click its thumbnail.

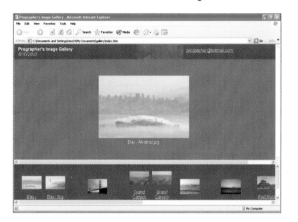 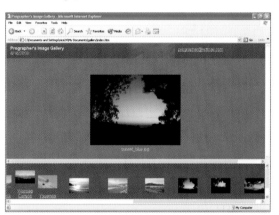

🔟 If a file name is very long, it increases the spacing between the images. For a more even spacing, keep the file names short or of consistent lengths.

Contents of the Supplementary CD

Insert the supplementary CD-ROM in your CD-ROM drive. You should see these two folders.

[Program] Folder

This folder contains a trial version of Photoshop Elements 2.0. Double-click on the 'Setup.exe' file in the [Photoshop Elements Trial - Win] folder to install the trial version of Photoshop Elements 2.0, which can be used for a period of 30 days.

[Sample] Folder

This folder contains the sample images used in this book, organized by chapters. Each chapter folder contains example files used in the Techniques section of the respective chapter and the [Final] folder contains the final Technique file.

Index

Acknowledgements

I would like to thank ED, Lasid and Simona for modeling for the pictures and also thank all the individuals who contributed photographs for this book.

Picture Copyright © 2003 Brianne Agatep: page 116, 162.

Picture Copyright © 2003 Bonnie Bills: page 140, 178, 184.

Picture Copyright © 2003 Carl Keyes: page 44, 169.

Picture Copyright © 2003 Derick Miller: page 78.

Picture Copyright © 2003 Ellen Bliss: page 51, 70.

Picture Copyright © 2003 Ji Yong Kim: page 38, 81, 96, 106, 116, 150, 160.

Picture Copyright © 2003 Judy Fung: page 34, 35, 41, 135, 155, 189, 191.

Picture Copyright © 2003 Larry M. Gottschalk: page 34, 36, 48, 53, 57, 91, 122, 133, 144, 145, 146, 184, 189, 191.

Picture Copyright © 2003 Mabel Lee: page 60.

Picture Copyright © 2003 Pete Gaughan: page 100, 131, 138, 172, 175.

Picture Copyright © 2003 Sang Hoon Lee: page 67, 87.

Picture Copyright © 2003 Sang Youl Park : page 76.

Picture Copyright © 2003 Thom Dyson: page 166.